... their kaleidoscope of colors and patterns, their sculptural forms and the variety of their universe... intertwined with their mythology and mystery.

(cover and back) №. 4 *Constructivist Beetle*, 2012
Metal armature, glass, paint, 60 x 60 x 10 inches

(this page) Detail of №. 59 *Amethyst Beetle*, 2012
Metal armature, glass, paint, 41 x 38 x 10 inches

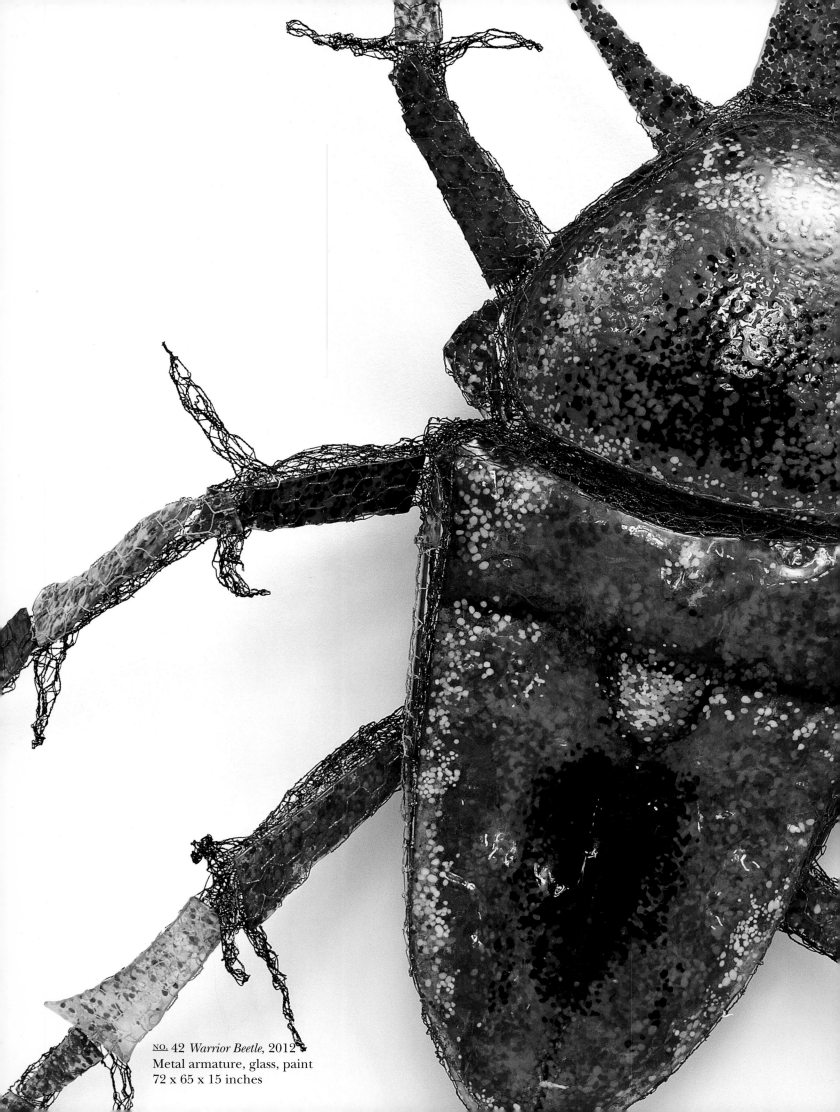

<u>NO.</u> 42 *Warrior Beetle*, 2012
Metal armature, glass, paint
72 x 65 x 15 inches

JOAN DANZIGER

Inside the Underworld

SCULPTURES

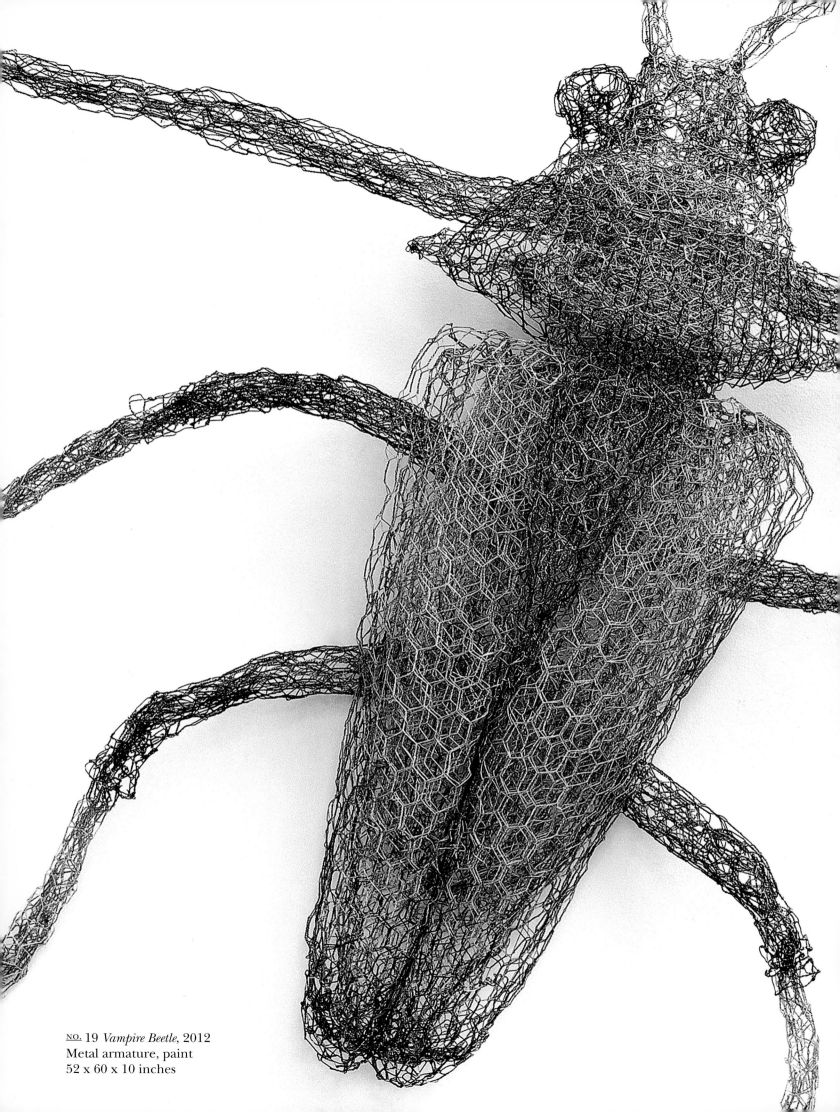

<u>NO.</u> 19 *Vampire Beetle*, 2012
Metal armature, paint
52 x 60 x 10 inches

FOREWORD

The American University Museum at the Katzen Arts Center is fortunate to be hosting an important new body of work by sculptor Joan Danziger. Her installation, *Inside the Underworld*, demonstrates why Danziger is a primary figure in the mid-Atlantic art world.

The first time I exhibited Joan Danziger was in a show titled *Child*, which I curated for young audiences over twenty years ago. I quickly realized that Joan's playful art was not only for children. It was serious play replete with mythological, zoological, and philosophical overtones. It can be appreciated by the young at heart from shortly after birth until the eyes no longer transmit images to the brain.

Flaming giraffes running and six-foot beetles clambering up walls only hint at the fascinating treats she offers. By turns scary and hilarious, their subject matter only tells part of the story because they are, first of all, works of art by a masterful sculptor. The level of craft, from pulped paper to slumped glass, is astounding. Danziger defies all categories because she is one of a kind. In the often-hermetic worlds of art and craft, Danziger is a cross-dressing diva.

With titles like *Flying Trees* and *Vampire Beetle*, you know you are in for an adventure. How satisfying that the adventure is aesthetic and fantastic at once!

Jack Rasmussen
Director and Curator
American University Museum

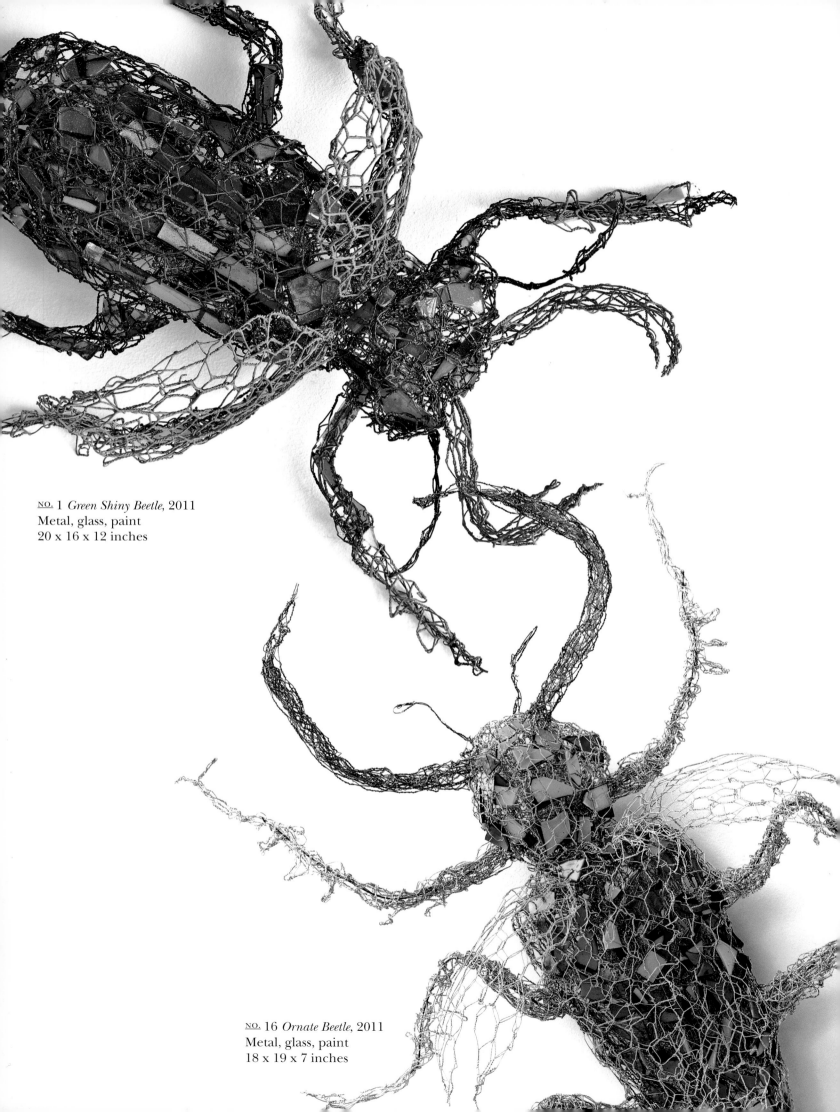

NO. 1 *Green Shiny Beetle*, 2011
Metal, glass, paint
20 x 16 x 12 inches

NO. 16 *Ornate Beetle*, 2011
Metal, glass, paint
18 x 19 x 7 inches

BRINGING THE DAZZLING UNDERWORLD TO THE SURFACE

by Ori Z. Soltes

In the opening words of a surreal story by Franz Kafka, Gregor Samsa awakens from his sleep and whatever might have been his dreams into a bright morning nightmare, a waking nightmare from which he can only be released by death. Kafka's "Metamorphosis" (1912) is the consummate symbol of existentialist alienation and depressive isolation. His helpless hero has no sense whatsoever of why or how he has been transformed into a giant insect. He has, moreover, for lack of a human physiology, lost the ability to speak. He is cut off from his own family, which regards him with horror, gradually losing all memory of *Gregor*, the human son and brother who existed before he became an insect. So his tiny world—confined to his bedroom until his demise—is a cruel one, in which he is fully aware that he has become hideous and hateful to those he loves.

Kafka's brief description of the insect Gregor suggests a beetle-like body, with its smooth domed back, segmented belly, six spindly legs and long, spindly antennae. The notion of a human being finding itself unaccountably and irrevocably transformed into an insect incapable of communication has, across both literature and visual art, offered a range of unhappy outcomes that connect the fantastical to the real by way of the magical and the surreal. But transformations and the universe of insects—in particular the order, *Coleoptera*, as beetles are called by entomologists—need not provoke dark visions. Alas, Kafka could not imagine that condition as anything other than hateful and hideous, for he lived too early to have come across Poul Beckmann's *Living Jewels: The Natural Design of Beetles*, with its scintil-

lating and color-bursting images of these tiny creatures offered in enlarged photographic format. He died more than 85 years too soon to see what Joan Danziger's eyes have seen—including Beckmann's book—which has led her in the past few years to produce dozens of exquisite sculpted, giant beetles of diverse configuration and proportion.

The walls, floors and table surfaces of Danziger's studio are crawling with dozens of lush, mega-sized "specimens," their front, "elytra" wings (*ptera* in Greek), hardened and thickened like a sheath (*koleos* in Greek) affording protection, neatly folded over the rear wings and over the beetles' bodies. Danziger arrived at this magnificent obsession through a series of aesthetic and intellectual passageways. Her reading is one: not only insect-focused books like Beckmann's, but the larger and longer literature of myth and the fantastic (with its elements of anxiety and fear) and the marvelous (without such elements). There is also her awareness of the history of art in its relationship to the supernatural and the dream-and-nightmare-surreal, from Egyptian statuary to Hieronymous Bosch's triptychs to Albrecht Dürer's watercolors; from Arnold Bocklin to Odilon Redon and Henri Rousseau to Marc Chagall.

And then there is the matter of her own metamorphoses as an artist who harnesses all this and more to her work. Or rather: Danziger's metamorphoses never seem to disconnect her work from certain consistent sensibilities. She began as an abstract painter whose coloristic thinking connected her

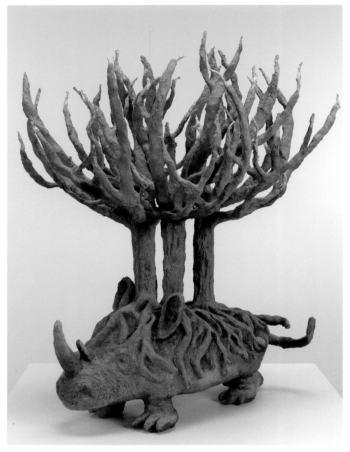

The Rhino Is A Tree… The Tree Is A Rhino, 2007
Mixed media, 31 x 27½ x 25 inches

back to Rothko and further, to Kandinsky. But her predilection for dramatic hues followed into her sculptures—from vivid, surreal flowers in vases resting on delectably-pigmented-and-patterned oriental carpets; to large, colorful acrobats and musicians; to brilliantly-hued parrots riding bicycles—went temporarily (but even then, never completely) underground in much (not all) of her more monochromatic work from the 1990s and the first seven or eight years of the new millennium; and has emerged with vigor in this bold new series of *insecta pterygota*.

Beetles are called *Coleoptera* (they are an order within the superorder, *Endopterygota*; within the infraclass, *Neoptera*; within the subclass, *Pterygota*; within the class, *Insecta*; according to Linnaeus' 1758 classification text—as long as you asked) because of those hardened "sheathed" protective front wings typically folded, dome-like, down their backs. (Gregor Samsa must not have had his coleoptera in place as he scurried away from his angry father—who threw an apple that, embedded in his son's back, ultimately helped hasten Gregor's demise and the sweeping of his dessicated carapace out with the dirt.) They have a long history in religious thought: nearly five millennia ago the Sixth-Dynasty Egyptians began to accord a unique status to a form of dung beetle known as the *Scarabaeus Sacer* (Sacred Scarab).

The hieroglyphic image of the scarab is read as *kh-p-r*—which corresponds to the root for the verb "come into being"/"transform" and is related in turn to the God, Kheperi ("he who has come into being/been transformed"), who is associated with the rising sun. Like the dung beetle, believed to exist only in male form and thus to reproduce/recreate itself (by depositing semen into a dung ball), Kheperi is self-created. Like the beetle (with its sunray-like projections of legs, antennae and head protrusions), pushing its pellet of dung up the dunghill, Kheperi rolls the sun above the horizon and across the sky, then down below the horizon at sunset, through the other world and back up toward the horizon at sunrise.

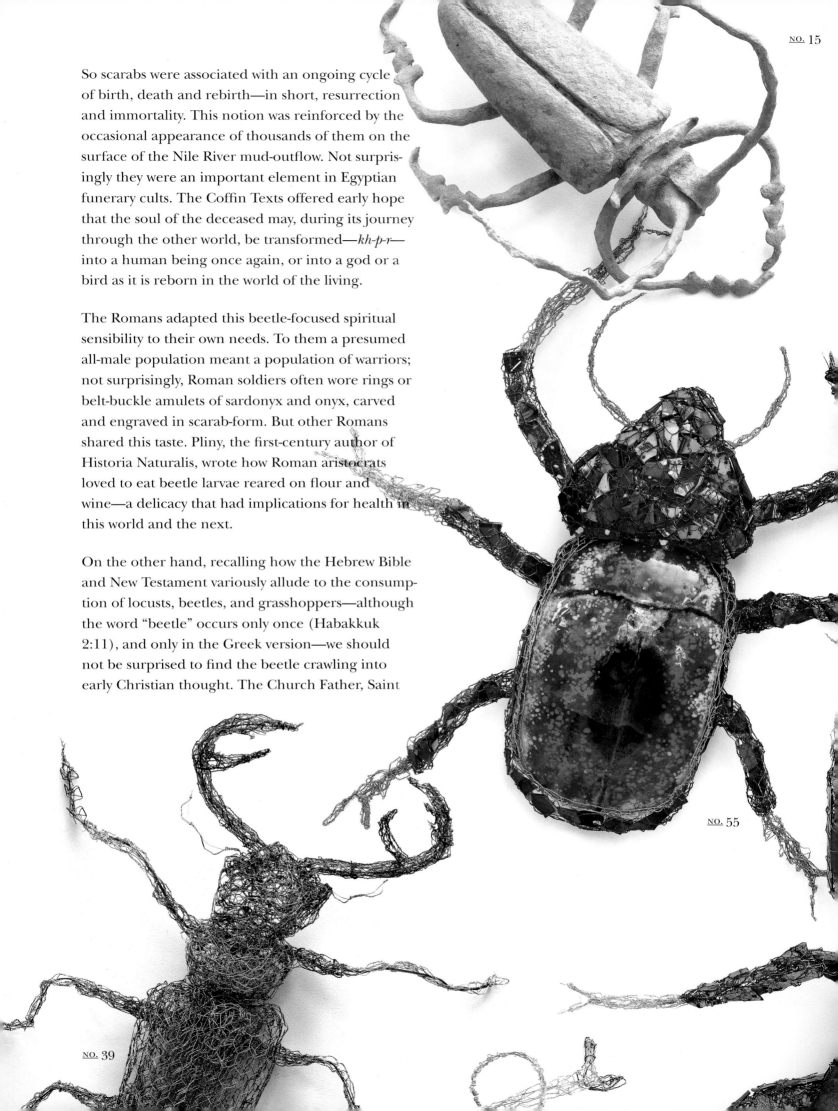

So scarabs were associated with an ongoing cycle of birth, death and rebirth—in short, resurrection and immortality. This notion was reinforced by the occasional appearance of thousands of them on the surface of the Nile River mud-outflow. Not surprisingly they were an important element in Egyptian funerary cults. The Coffin Texts offered early hope that the soul of the deceased may, during its journey through the other world, be transformed—*kh-p-r*—into a human being once again, or into a god or a bird as it is reborn in the world of the living.

The Romans adapted this beetle-focused spiritual sensibility to their own needs. To them a presumed all-male population meant a population of warriors; not surprisingly, Roman soldiers often wore rings or belt-buckle amulets of sardonyx and onyx, carved and engraved in scarab-form. But other Romans shared this taste. Pliny, the first-century author of *Historia Naturalis*, wrote how Roman aristocrats loved to eat beetle larvae reared on flour and wine—a delicacy that had implications for health in this world and the next.

On the other hand, recalling how the Hebrew Bible and New Testament variously allude to the consumption of locusts, beetles, and grasshoppers—although the word "beetle" occurs only once (Habakkuk 2:11), and only in the Greek version—we should not be surprised to find the beetle crawling into early Christian thought. The Church Father, Saint

NO. 55

NO. 39

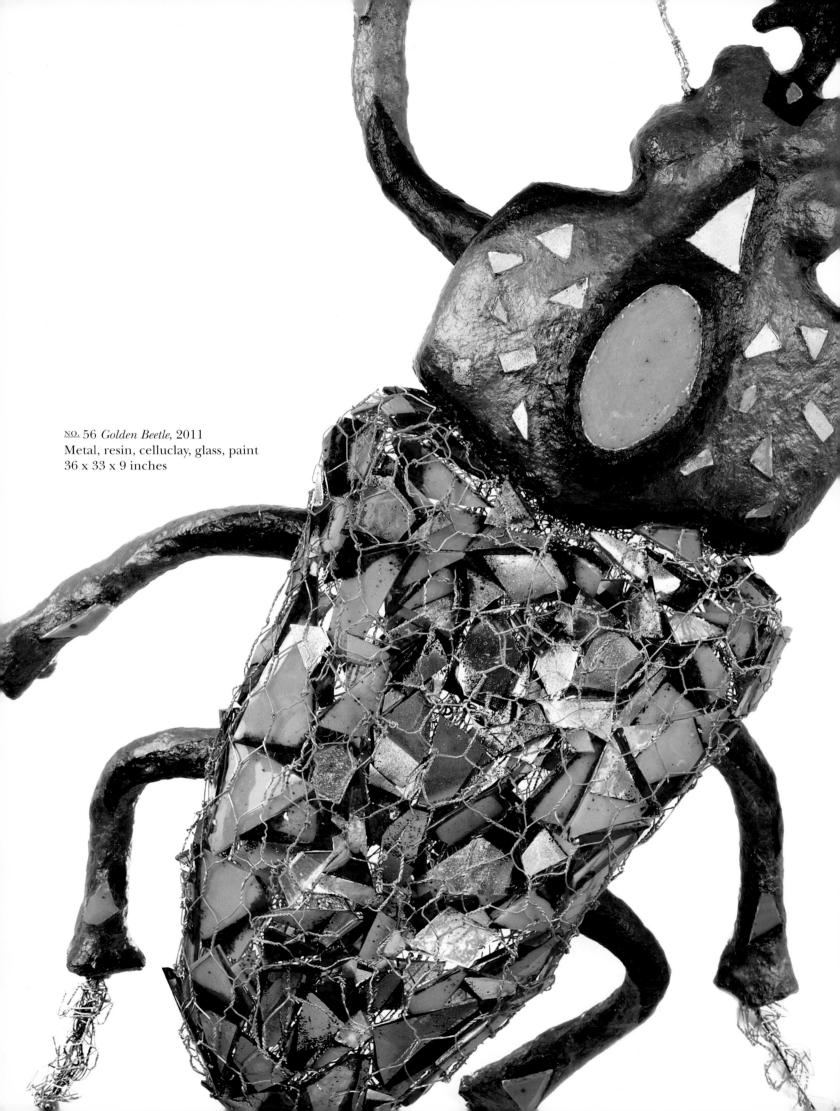

NO. 56 *Golden Beetle*, 2011
Metal, resin, celluclay, glass, paint
36 x 33 x 9 inches

"…sculptures [have always] combine[d] an interplay of animal strength and beauty of nature with the human spirit. They evoke mysterious and secret worlds, drawing upon my fascination with dream imagery and metamorphosis. The use of animal imagery as metaphorical subject has great potency for me; it gives my sculptures a life of their own and creates a magical world."

Ambrose, alluded to the Habakkuk text on five occasions, comparing Jesus to the prophet's scarab image. Other early Christian writers, like Saint Augustine and Saint Cyril of Alexandria, made similar allusions, and the idea was reinforced by late pagan Egyptian references to the scarab as "only begotten (monogenes)"—the very turn of phrase used in John 3:16 to refer to Christ, and repeated by other Christian authors. Dürer, following this tradition, not only did water colors of scarabs, but associated the Stag Beetle with Christ in several paintings.

As for the Egyptian gods who attend the journey of the soul, like other Egyptian gods, they are represented with human bodies and, (aside from Osiris and Isis), with animal heads. And as Joan Danziger metamorphosed as an artist from painting to sculpture, she was drawn, early on, to the shaping of beings with just this sort of combination of physical elements. Works from the 1970s and 1980s include many that offer gigantic animals—in particular cats (sacred, too, to the Egyptians) and birds (symbols of the soul across a panoply of cultures and religious traditions)—dominating the human inhabitants of her compositions. Or they offer hybrids. Works like "Flying Lavinia", with her striped zebra torso and head; or "Bird Lady"; or "Waiting Room," its two

main figures gazelle-headed and rhinoceros-headed—take their place among the religious, mythological and folkloric traditions that connect Egypt's Anubis and Sekhmet, Horus and Thoth (and others) to Greek centaurs and sphinxes and to medieval werewolves and demons.

Danziger's animal vocabulary, as it extended into the 1990s and beyond, also included horses and giraffes and rhinoceri—and combinations drawn from various traditions and her own fertile imagination. Griffins, with their lion bodies and bird-of-prey heads and wings shared conceptual space with her dominating *The Rhino Is A Tree… The Tree Is A Rhino* (2007). (page 10) This last work, a marvelously idiosyncratic monochrome masterpiece—part, then, of her oeuvre not only devoid of pigment, but grey as if a layer of volcanic ash has enveloped it all—offers a quartet of leafless, crusty-barked oak-like trees, their roots wrapping around and digging into the equally crusty hide of the rhino with his tree-trunk-like legs. The trees' tangled branches reach heavenward like his horn. The sculpture not only entangles—literally—the natural worlds of flora and fauna into a unique hybrid. It stands among an entire extended series of works that embed all sorts of creatures within and among diverse arboreal compositions.

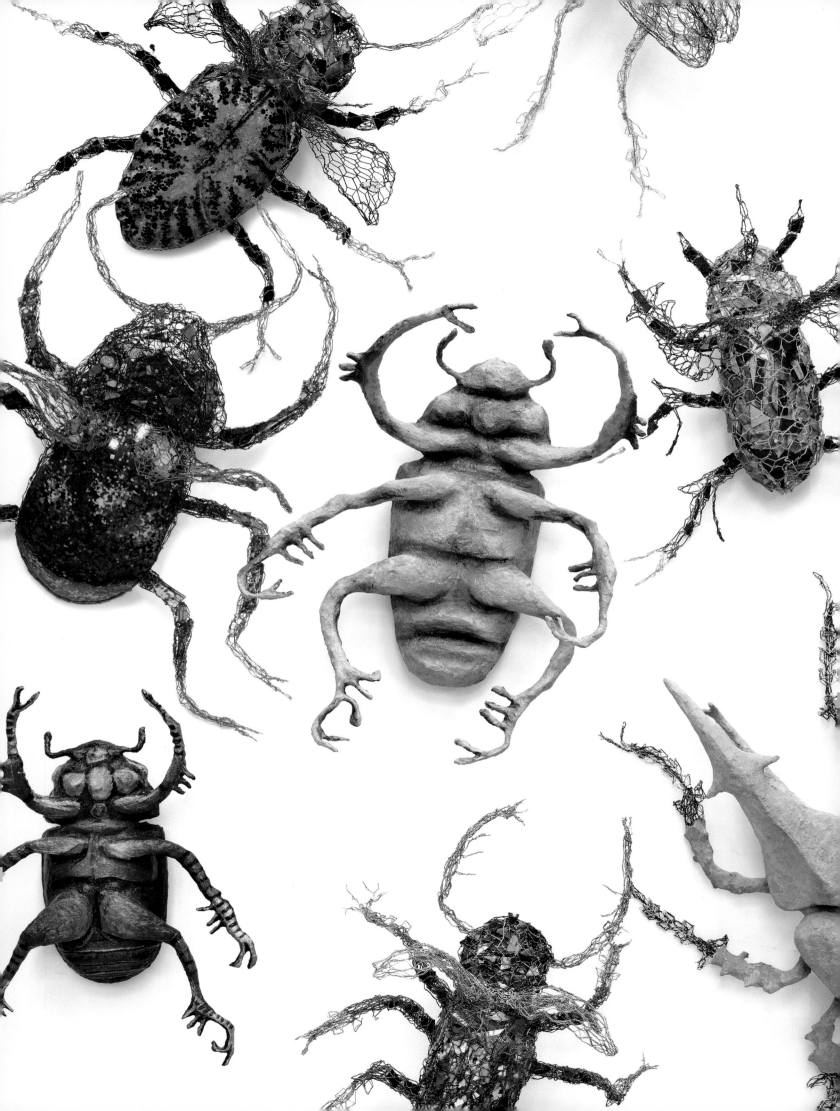

The artist made an extensive study of trees during that period, so that some of her works, particularly ones where she returned to bright colors, may be identified as specific, if stylized, tree-types: elements of nature that she has transformed into unnatural—or supernatural—dreamscapes in which human beings and familiar or phantasmagorical animals cavort or quietly meditate. Each tree complex, drawn from a world-wide exploration, is defined by its own aspects.

Of course, trees serve as symbols in a range of spiritual traditions. The broad sense of human possibility with its delicate balance of male and female elements—and the question of human death and immortality-through-offspring-and-through-artistic-creation—informs the trees created by Danziger: male with their phallic symbolism, female with their multiple expressions of fertility: leaves, flowers and fruits. Moreover, as that series progressed, aside from returning to color as an element—first with occasional whites and then with bright yellows and reds, greens and oranges—she began to allow parts of their underpinnings to show. The wire that forms the substructure for resin-reinforced fabric and celluclay or archival paper either peeks out from the upper reaches of tree branches or is fully exposed, from roots to branches.

Throughout the sweep of her specific artistic foci, Danziger's "…sculptures [have always] combine[d] an interplay of animal strength and beauty of nature with the human spirit. They evoke mysterious and secret worlds, drawing upon my fascination with dream imagery and metamorphosis. The use of animal imagery as metaphorical subject has great potency for me; it gives my sculptures a life of their own and creates a magical world," she has said.

All of these elements, issues and ideas have been further examined and transformed in the vast army of beetles to which the artist has devoted such intense recent efforts. Like her trees, each of her beetles has its own individual personality. Each has its own "name," in fact, so that—in a process that one might see as opposite to that in which Gregor Samsa is dehumanized through his insect physiology and

through being rejected and abandoned—many are not only outsized but anthropomorphized. We cannot miss these large, colorful jewels, their singular personalities reflected upon by the artist in blazing colors and diverse textures.

She explores and expresses their biodiversity—there are more than 400,000 described species of beetles and perhaps as many as ten times that number that remain undescribed to date—as aesthetic diversity. As with her earlier tree series, she began with ash-colored celluclay, so that one feels, with these, as if one has chanced upon the results of the excavation of some coleopteran Pompeii. But the abstract painter within the artist could not resist the stunning pigments suggested by her research and by the images in books like that by Beckmann. So (as with her earlier hybrid animals and trees) she began to paint some of them with deep, rich acrylic layers of green, blue, red, orange, black and gold. Sometimes she chose to expose the wire skeleton of parts of her subjects—or their entirety.

There is both biological irony and a twist to art history with these last ones. The irony is that, by definition, beetles are among the many groups of insects with no internal skeleton; the hardened exterior carapace is the skeleton: the exoskeleton. So aside from the fact that she reverses reality by creating them as she does, she not only presents the viewer with a reality that does not exist in nature in the way she presents it, but follows a modernist tradition that began with impressionist painting, of allowing the viewer to see the process and complete the artistic product with his/her own mind and eyes (for one can see the brush hairs still embedded in the thick, uneven surface of a Monet canvas, and since the focal length of every viewer's eyesight is unique, an individualized distancing from the canvas is necessary for the blobs of paint to coalesce as the intended image).

There is more to this art history than impressionist painting; it carries Danziger's aesthetic choices back to the Greeks—in two ways. One is that, in creating her own creatures the structures of which do not simply copy their real-life models, she is part of a long artistic process of disproving Plato's mistaken

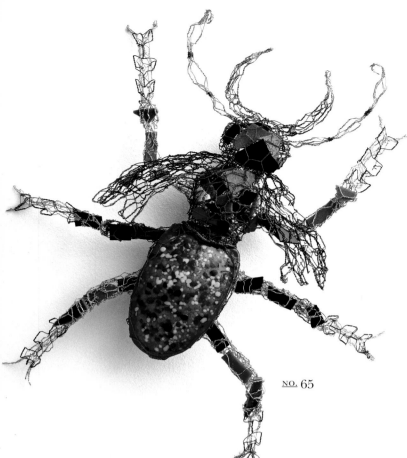

theory of art. For he claimed that artists merely imitate reality, whereas artists have always re-visioned, transformed, re-shaped and recreated reality. No works more literally show the viewer this than these beetles with their exposed inner structures.

So, too, Greek (especially Athenian) artists became obsessed by the Classical period (ca. 500-400 BCE) with visually exploring and expressing a range of dynamic, paradoxic contrasts. Divine/human and male/female contrast are the consummate pairs: Classical Greek art portrayed physically perfect—god-like—humans beings and by the fourth century gods were being depicted increasingly as human—imperfect. In the Hellenistic period the motif of hermaphrodites, with both male and female attributes, became popular. One way in which dynamic and paradoxic ideas might be shown visually was by offering the paradox of revealing and concealing—by sculpting parts of the human form as if covered by material so delicate that all of the contours were visible. Danziger's beetle sculptures also address this issue as they play between revealing and concealing their inner workings—but on her own terms.

Some of those inner workings may be seen even when she covers them in the medium introduced

into her work with this new series: glass. Fused silica glass with abstract colors and patterns began with the Phoenicians and/or Egyptians; the Romans and Byzantines carried it forward with rich mosaic floor and wall decorations made of little squares (tesserae) of glass. They occasionally embedded individualized miniature portraits in glass. Danziger's enlarged individuated beetles, echoing the endlessly diverse colors and textures accorded to their exoskeletons by nature, are diversely defined by abstract patterns—triangular shapes, amorphous blobs, scattered dots—spilling over those folded wings. The rich colors and smooth and sleek or rhinoceros-hide rough textures provided by the glass frit , (glass pebbles, fused into the glass slabs), that she and her assistants have sometimes interwoven, tessera by tessera or slab by geometric slab within the skeletal mesh of wire, or sometimes slumped in the hot kiln over the wire armatures—occasionally combining a glass exoskeleton over the body and painted cel-luclay over the head—interweave a long biological history with a long art history and religious history.

Her creatures all have six spindly legs, but no two sets are identical. Some have outspread rear wings the delicacy of which is articulated by the naked wire and others have those wings "folded" under the elytra wings. They all have antennae (but no two sets are alike) and some have pincers or, in the case of her Rhinoceros beetle, a long, upwardly-curved horn. Perhaps my personal favorite (it's hard to choose) is her Hercules Beetle, so-named because of the inordinate strength that the real-life Hercules Beetle manifests relative to his size. I love his color—and the fact that Hercules (Heracles, in Greek) is the consummate hybrid. He is a border creature: his father the chief Greco-Roman god, Zeus-Jupiter, his mother a mortal; he dies but lives eternally up on Olympus.

Heracles and other heroes are like prophets and priests, mediating between human and divine realms. Most of art across history serves religion by depicting gods or visually expressing the divine relationship to us. Thus every artist is also like a priest or prophet, a border creature, mediating between external reality and the internal reality of

the mind and imagination. Certainly this is true of Joan Danziger. She connects to and emulates divinity in being a creator of her own worlds. However diversely informed and however apparently secularized, her work argues spiritually against an overly human-sourced industrial reality, by means of a unique vision.

Danziger is an artist whose vast curiosity and ongoing, forty-year search for imagery that is beyond the everyday has come, for now, to rest on the vast and varied everyday reality of coleoptera. She brings a sensibility that, in spite of her sculptural medium, is suffused with and has been likened to that of key chromaticist abstract expressionists like Mark Rothko and Barnett Newman—and the way she paints with luminous glass on wire armatures (rather than with oil or acrylic on canvas) on her beetles underscores this.

Her own metamorphoses are consistent with those of her subjects and with what it is that attracted her to them in the first place: "their kaleidoscope of colors and patterns, their sculptural forms and the variety of their universe... intertwined with their mythology and mystery." Through myriad passageways she has come to create an extraordinary array of magisterial and marvelous creepy-crawly jewels.

Far from the stuff of Kafkaesque nightmares, they force the viewer to rethink and re-vision—and thus to participate in recreating—the world below, above and around us.

ORI Z. SOLTES

Ori Z. Soltes is a professor at Georgetown University, Washington, DC, where he teaches across a range of disciplines, from art history and theology to philosophy and political history. He is the former Director and Curator of the B'nai B'rith Klutznick National Jewish Museum where he curated over 80 exhibitions. He is the author of over 215 books, articles, exhibition catalogues, and essays on a range of topics. Recent books include: *Fixing the World: Jewish American Painters in the Twentieth Century* and *Our Sacred Signs: How Jewish, Christian and Muslim Art Draws from the Same Source*. His lectures for the Teaching Company consist of 48 DVD on the History of Art.

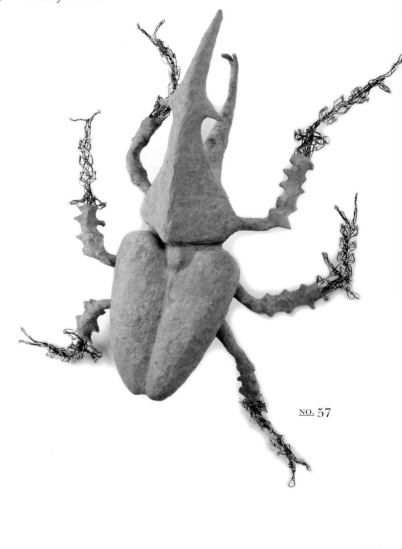

NO. 57

NO. 51

15

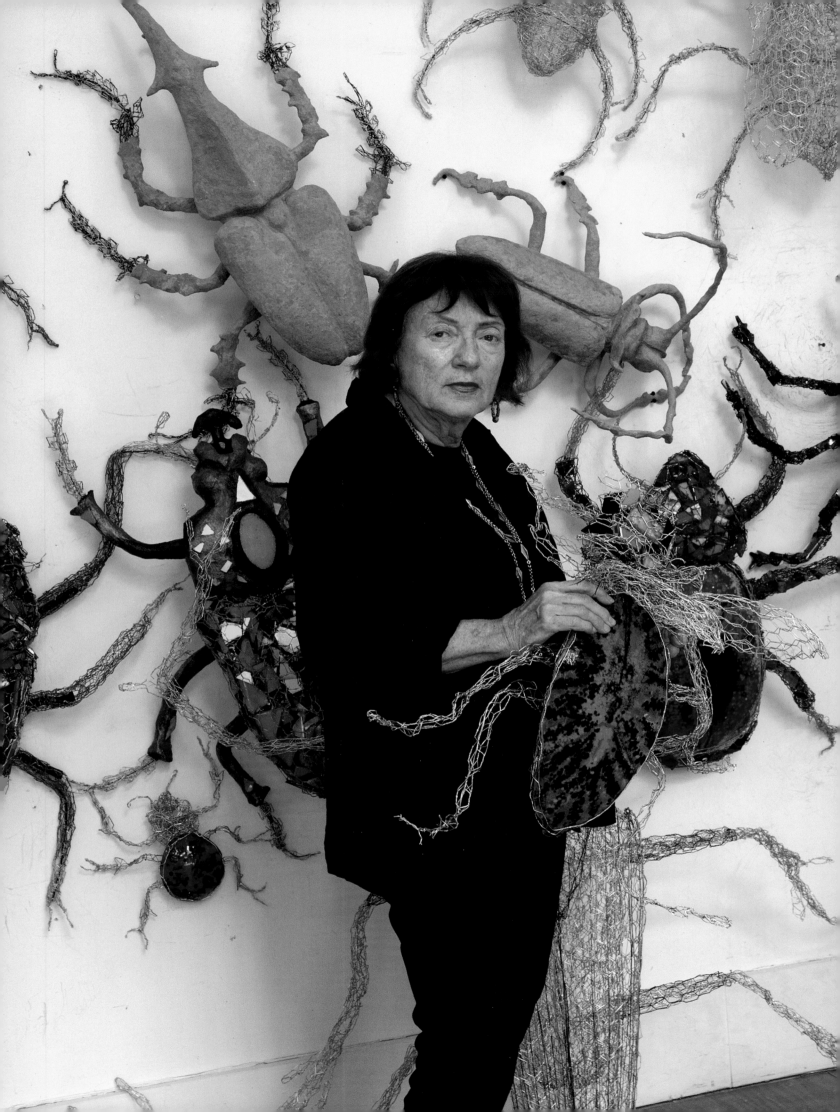

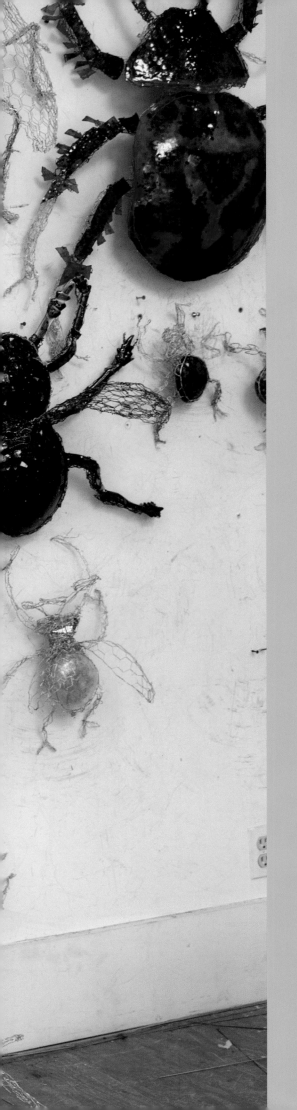

ARTIST STATEMENT

My sculptures use animal imagery as metaphorical or psychological subjects giving the sculptures a life of their own and creating a magical world. Beetles, especially the scarab, have inspired creative myths in many cultures because of their ability to survive and have been objects of fascination and awe. This site-specific installation of beetle sculptures combines my interest in mythology and metamorphosis, incorporating many aspects of their complex life cycle while also exploring their phantasmagorical diversity of shapes, colors and sizes. They have been created in many altered stages of being, first formed in wire and then emerging from the ground covered with ash, then in iridescent colors of glass or paint.

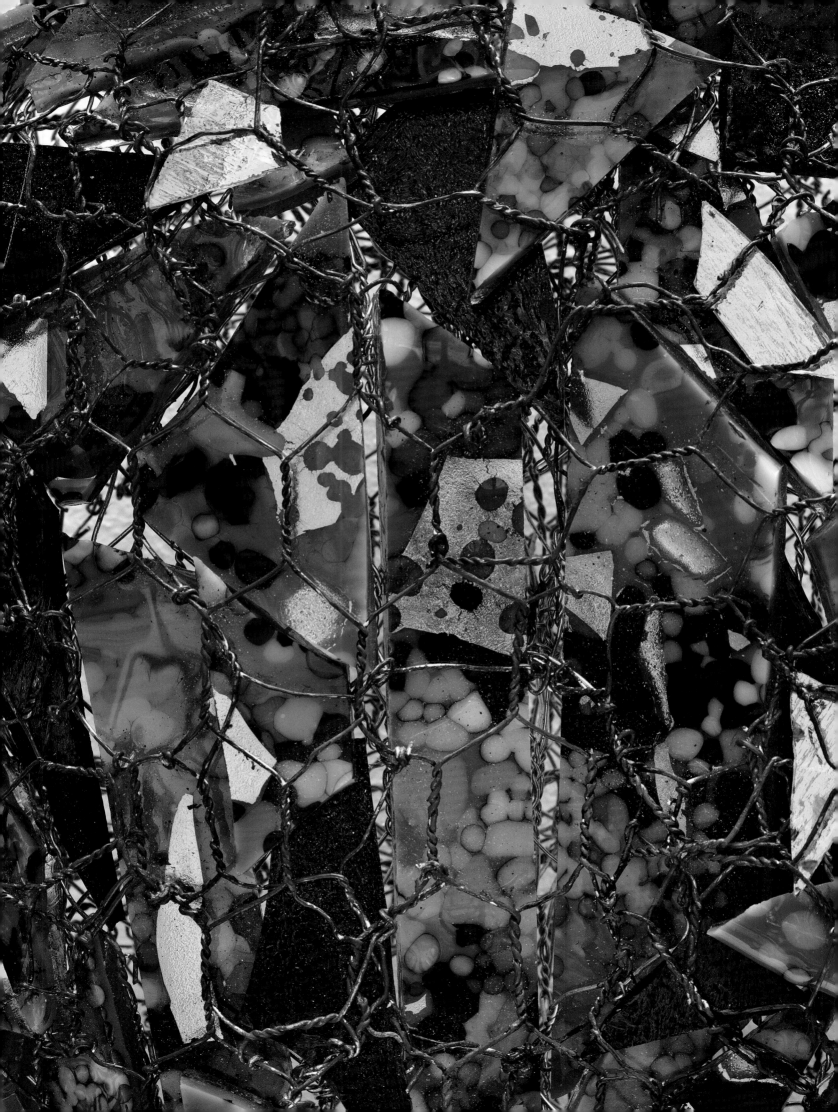

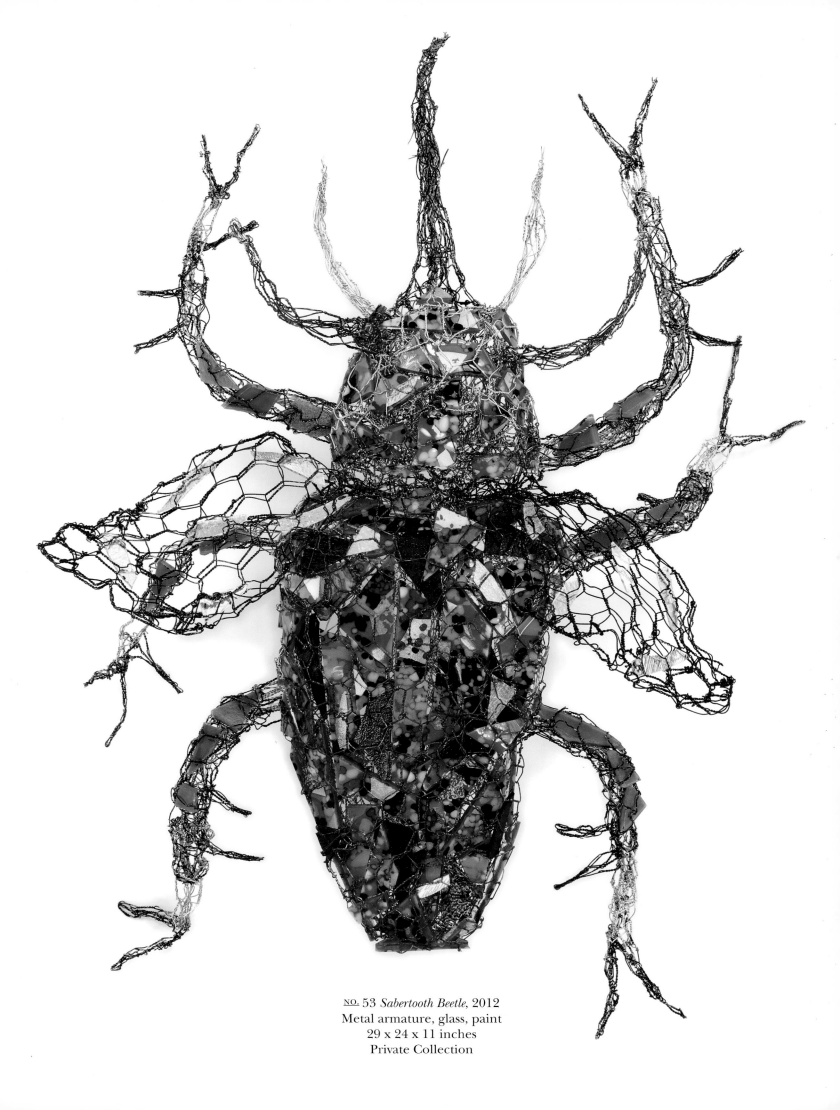

№ 53 *Sabertooth Beetle*, 2012
Metal armature, glass, paint
29 x 24 x 11 inches
Private Collection

IN THE REALM OF THE BEETLE

by Elaine A. King

An exhibition of Joan Danziger's art is always a surprise. One never knows what they will discover since she is always evolving and delving into new zones of investigation. However the connective link throughout her oeuvre has been a focus on the world of animals, mythological creatures and the terrain of the peculiar. In her previous show one came across Lilliputian-like, uncanny sculptural assemblages of trees and mythical animals that required viewer close scrutiny.

Danziger's magical constructions continually evince a poetic innocence and her work transports viewers into zones of ambiguity. Always she recognizes the supremacy of nature and time's inevitable effect on all matter. In this new body of work she examines the realm of the Beetle. To the ancient Egyptians this common beetle, the scarab, symbolized hope and the restoration of life. Perhaps because of the sharp protrusions on a scarab's head that mimics the sun's rays, the Egyptians linked the scarab to their sun god, Khepera. According to her "Beetles especially the scarab, have inspired creative myths in many cultures because of their rebirth and immortality. I believe the legends associated with them about the life and death cycle in Ancient Egypt and other societies." Danziger's new interest in beetles may come of a surprise to some since most adults either hate insects or can't be bothered with them. In urbanized western societies few people have had little first hand experience with insects, other than flies and mosquitoes. However, children are innately drawn to the whimsical pastime of dismembering insects due to sheer curiosity and the desire to comprehend what makes them tick underneath all of their chitosan armor. Joan Danziger too finds bugs most fascinating and holds a strong aesthetic appreciation for their complex forms and incandescent colors. She is aware that throughout history they have been powerful subjects for artists. Graham Sutherling, M. C. Escher, and James Ensor all used them in their works of art and were as well the subject of many Asian paintings. Nature in all its aspects is sacred in Japan. It is integrated in the Shinto belief that worships the spirits of the mountain deities, the rivers, the trees, and even insects. The book *Japanese Ink Painting As Taught By Ukai Uchiyama* (1960) contains the passage: "Insects, in their modest way, add life to a painting...." Among Chinese and Japanese artists insects were popular subjects. They were depicted in the 9th century, Chinese paintings whose main theme was birds, perhaps because they are the birds' preferred diet and insects are attracted to flowers, and thus appear in flower paintings, and in bird-and-flower paintings (*kacho-ga*).

Danziger claims, "This netherworld gives me great inspiration to create a sculptural installation incorporating many aspects of their complex life cycle. The phantasmagorical diversity of their shapes, sizes, iridescent colors, patterns and textures have lead me to a complex sculptural interpretation of these amazing creatures who I feel have a magical purpose and meaning."

Beetles represent the largest category of insects, containing over 250,000 illustrated species. Among the beetle groups there are dung beetles, ground beetles, ladybird beetles, tiger beetles, water beetles and the celebrated scarab beetles. In ancient Egypt the scarab beetle (kheper) was believed to be a symbol of the God that would bring in the sun every morning and remove it at night. The ray-like antenna on the beetle's head and its practice of dung rolling caused the beetle to be associated with solar

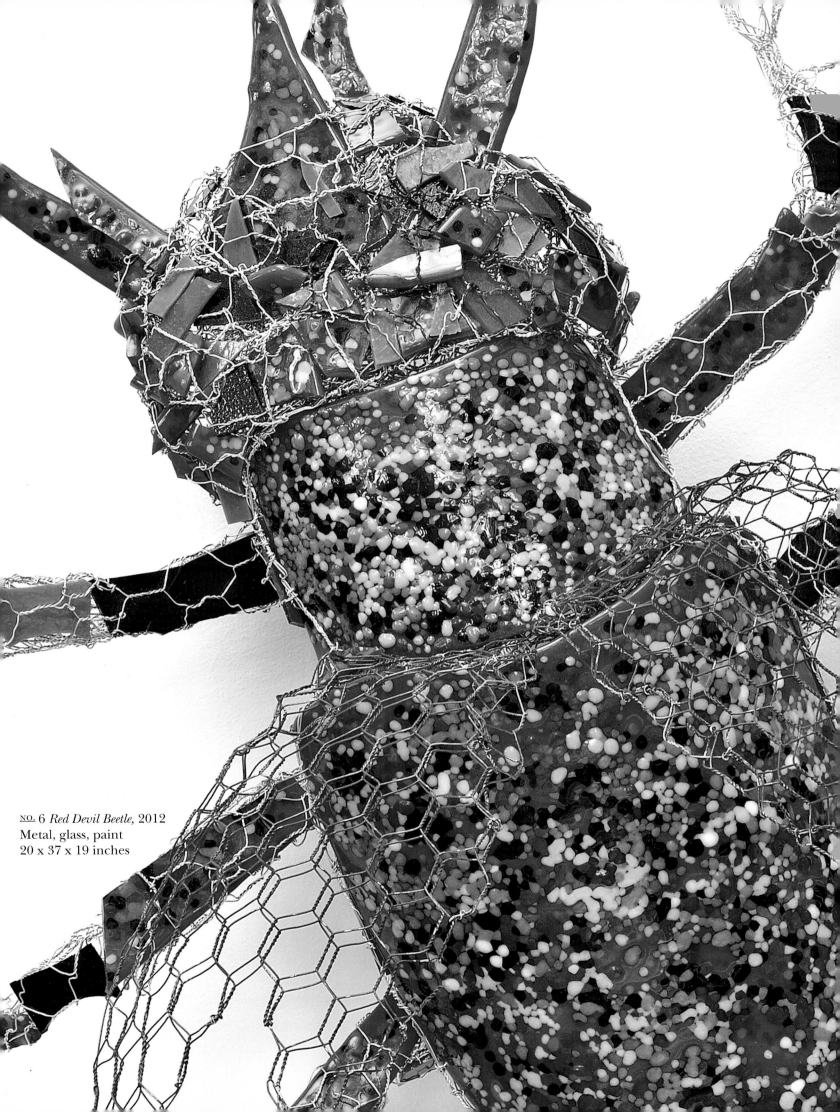

NO. 6 *Red Devil Beetle,* 2012
Metal, glass, paint
20 x 37 x 19 inches

symbolism. The scarab-beetle god Khepera was believed to push the setting sun along the sky in the same manner as the beetle with his ball of dung. In many artifacts, the scarab is depicted pushing the sun along its course in the sky.

Their unlimited forms, colors and behaviors make insects logical candidates for artistic expression. They have provided Danziger with novel references to translate into shape, mood and message. Her new work is a departure from past sculptures that placed focus on a single form or grouping. Although each beetle is meant to stand as a complete entity, together this collection of beetles come together to construct a dynamic site-specific installation designed to transform the perception of the space of the American University Museum at the Katzen Arts Center. Her re-contextualization of the beetles endows them with an ability to comment on man's existential condition after their death as well as presents the range of beauty within each specific species.

The expectations that a viewer might bring to this installation will influence their reactions to Danziger's specialized insect environment. The range of one's responses can vary from the surreal, dreamy or off-putting. Perhaps what one might keep in mind when examining this unusual display of inherently provocative forms is what the artist believes: "They are a wonderful visual territory to explore with their intertwined mythology and mystery." This fantastical assemblage ranging in size, form, opacity, durability, surface texture and color provides the viewer with an opportunity to step into an unfamiliar world. Some may not realize that beetles repeatedly have been a cultural inspiration internationally as symbols and metaphors for human existence and renewal.

ELAINE A. KING

Dr. Elaine A. King is a professor of the history of art and theory, and museum studies at Carnegie Mellon University. She is also a freelance critic, curator and a co-editor with Gail Levin of the book Ethics and the Visual Arts. American University selected Dr. King to be the Distinguished Art Historian-in-Residence for the International Program in Corciano, Italy, in Fall 2006. In 2000 and 2001 she was a Senior Research Fellow at the Smithsonian's American Art and National Portrait Gallery. Dr. King served as the executive director and curator of the Carnegie Mellon Art Gallery (1995-1991). She was the executive director and chief curator of the Contemporary Arts Center in Cincinnati (1993-1995), immediately following the Robert Mapplethrope debacle.

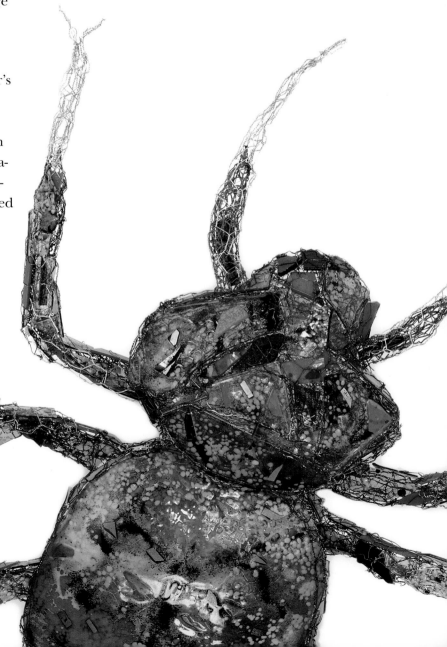

NO. 54 *Emerald Beetle*, 2012
Metal, glass, paint
20 x 37 x 19 inches

22

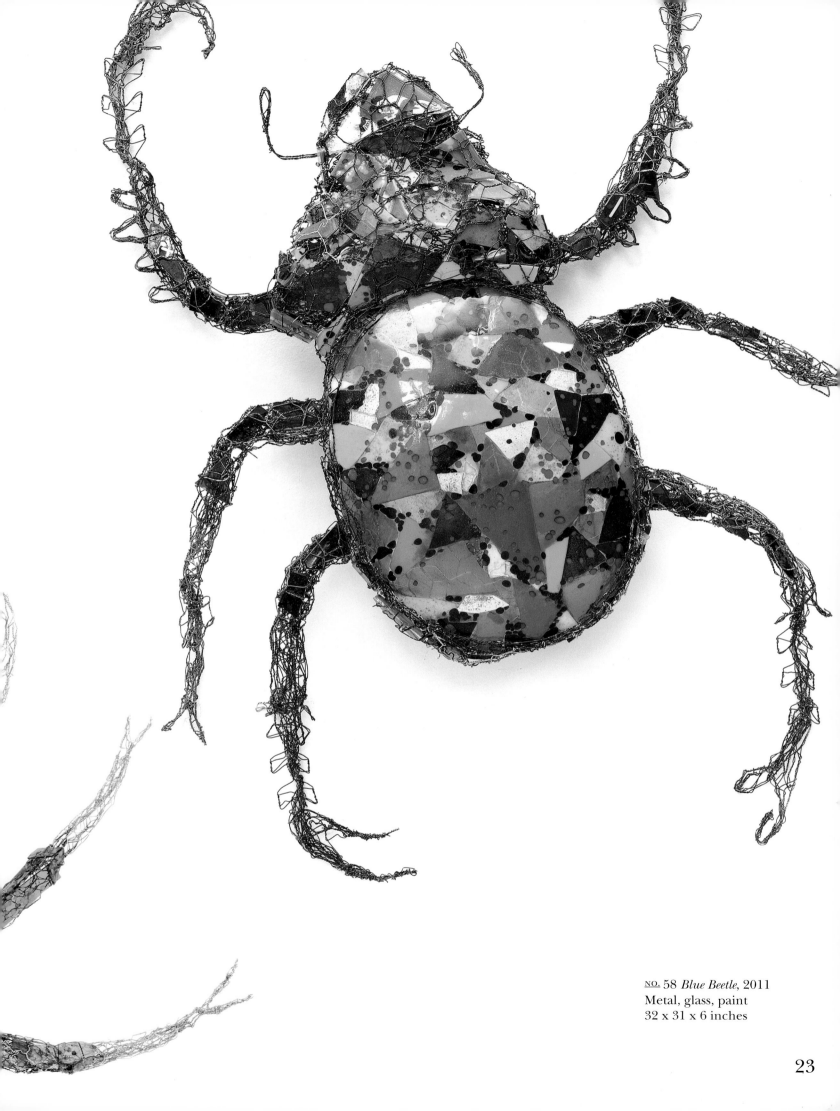

№ 58 *Blue Beetle*, 2011
Metal, glass, paint
32 x 31 x 6 inches

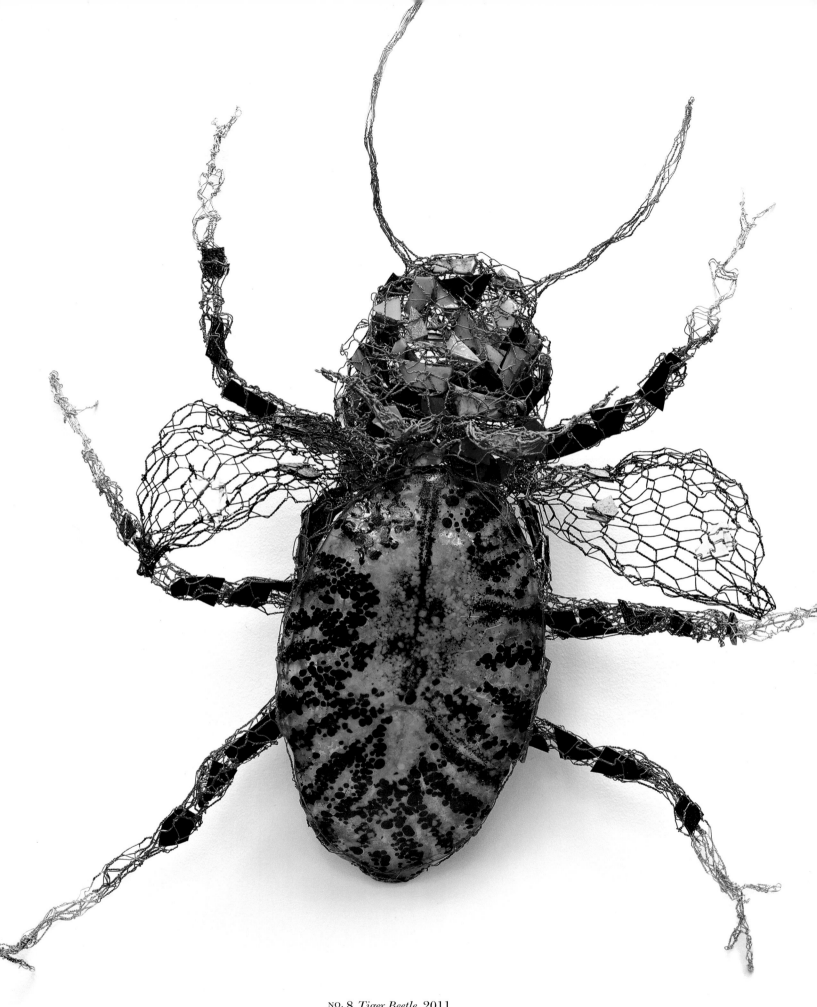

NO. 8 *Tiger Beetle*, 2011
Metal, glass, paint
38 x 28 x 14 inches

HYBRIDS: ART AND SCIENCE
JOAN DANZIGER'S SCULPTURES

by Lenore D. Miller

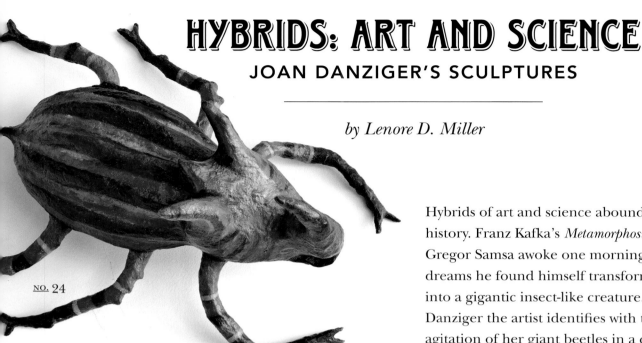

NO. 24

"Kafka's Castle stands above the world like a last bastille of the Mystery of Existence…"

—Lawrence Ferlinghetti, *Coney Island of the Mind*

The artist tackles the "unbeautiful" and makes it compelling. Instead of recoiling at the sight of huge beetles scaling the walls, we are enchanted by their endless variety of color and shape and how cleverly they animate the space. Danziger imagines new forms and creates variations on a "theme." Metamorphosis is the key, as these sculptures transform into creatures not found in nature, having evolved out of the artist's imagination.

Materials are revealed and wired structures twist, where formerly the underlying supportive elements were sheathed in opaque substances such as celluclay.

Slumped glass and mosaic-like and iridescent glass, twisted metal wire composes these animated designs. Some of the sculptures mimic the lifecycle from larval to fully developed creature, emerging from the ground, covered with ash-like celluclay, and then vividly colored.

Hybrids of art and science abound in cultural history. Franz Kafka's *Metamorphosis* relates, "As Gregor Samsa awoke one morning from uneasy dreams he found himself transformed in his bed into a gigantic insect-like creature." Like Kafka, Danziger the artist identifies with the implied agitation of her giant beetles in a confined architectural setting; this is Joan's foray into installation art, taking on the challenging space, two storeys of the American University Museum, Katzen Arts Center. The sculptures range from about a foot to six feet in height. The change of scale plays an important role in the visual impact, as do the intervals between sculptures.

The impact of beetle symbolism in 19th century visionaries manifests in the life of Henry Ulke (1821-1910) artist/entomologist in Washington, D.C. He was a famed portrait painter, a personal friend of Lincoln's, musician, and all-around notable character. His collection of *Coleoptera* collected over a period of 50 years was purchased by the Carnegie Museum. The scarab beetle (*Scarabaeus sacer*) of ancient Egypt depicted in many artifacts found in tombs was symbolic of regeneration and immortality, as it was portrayed grasping the sun disk. This beetle (kheper) was famous for rolling balls of dung along the ground and depositing them in its burrows. The female would lay her eggs in the ball of dung. When they hatched, the larvae would use the ball for food. When the dung was consumed the young beetles would emerge from the hole. Therefore they were worshipped as "Khepera", which means "he was came forth." This creative aspect of the scarab was

associated with the creator god Atum. [http://www. egyptianmyths.net/scarab.htm]

The work of Ernst Haeckel, *Art Forms in Nature* (published in 1904) inspired designers. Art Nouveau jewelry and its decorative motifs drew from the ebb and flow of natural forms. As a wry statement about exposing oneself to public criticism, Stanley Kunitz (Poet Laureate Consultant in Poetry to the Library of Congress 1974 and 2000) describes the practice of the tortoise beetle, "The larva…has the neat habit of collecting its droppings and exfoliated skin into a little packet that it carried over its back when it is out in the open. If it were not for this fecal shield, it would lie naked before its enemies." ("Three Small Parables for my Poet Friends").

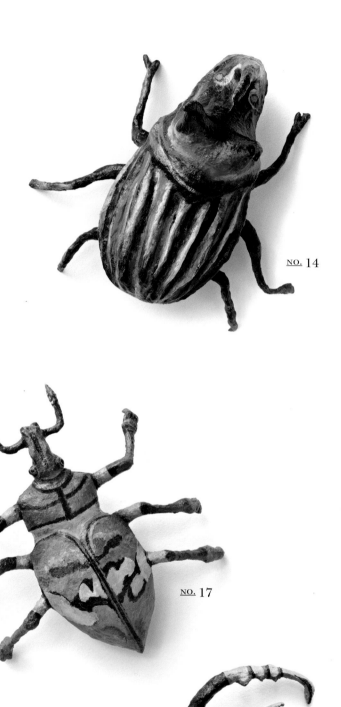

NO. 14

Books illustrated by Maria Sibylla Merian inspired the youthful Vladimir Nabokov. When a student at Cornell, Danziger took many seminars with the author and was influenced by his visual mind. He was an avid naturalist whose classification of butterfly species using traditional microscopic comparisons of their genitalia was proven posthumously through genetics. He is said to have loved detail, contemplation, symmetry, and asymmetry. Both his science and his writing were informed by these traits. Likewise, Danziger's work in the visual arts is also characterized by attention to detail and rich embellishment of surfaces.

NO. 17

Joan Danziger is fascinated by and inquisitive about the world around her. These macro creatures invade our space larger than life and yet they are mysterious and otherworldly in their configurations.

LENORE D. MILLER

Director and Curator of the Luther W. Brady Art Gallery at George Washington University, Washington, DC. She has curated hundreds of exhibitions and also the first exhibition held at the National Building Museum on the metalwork of Samuel Yellin. Lenore Miller is a professorial lecturer in Fine Arts and Art History at George Washington University.

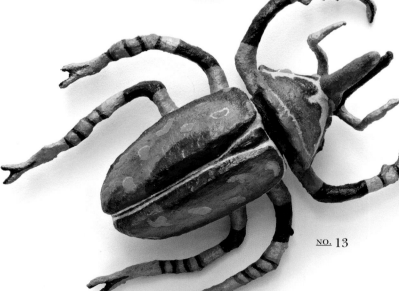

NO. 13

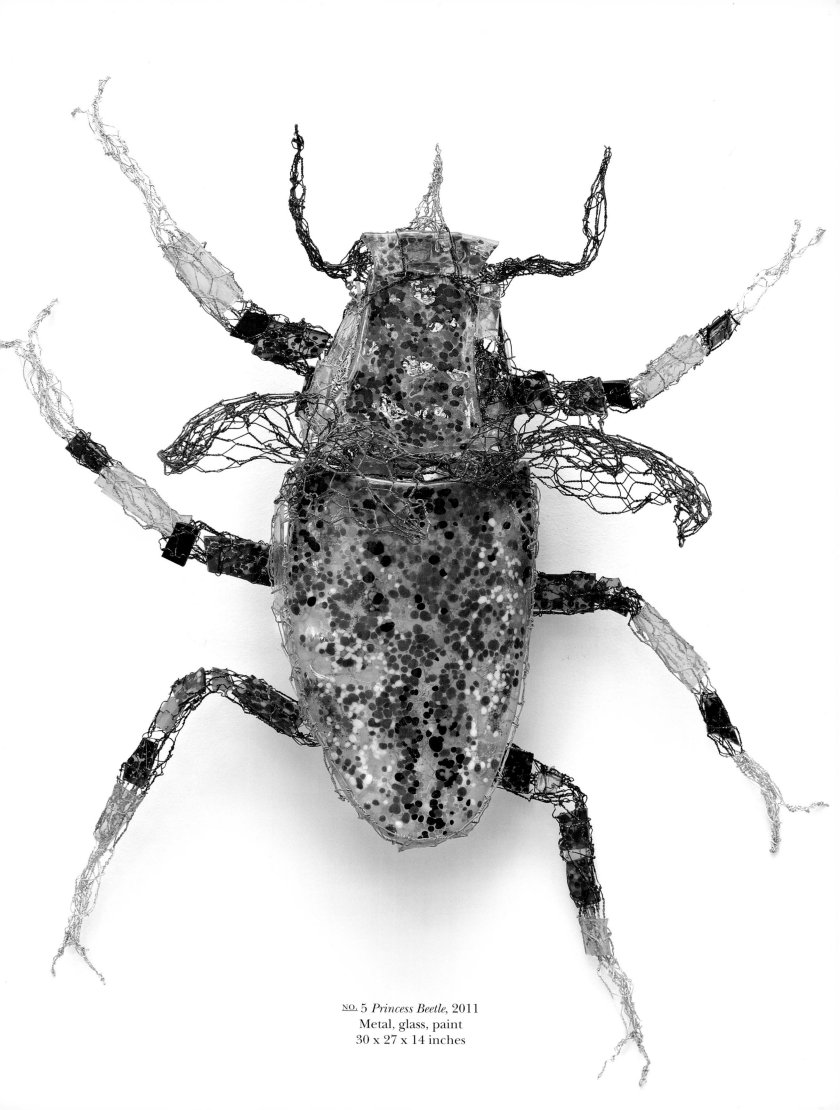

NO. 5 *Princess Beetle*, 2011
Metal, glass, paint
30 x 27 x 14 inches

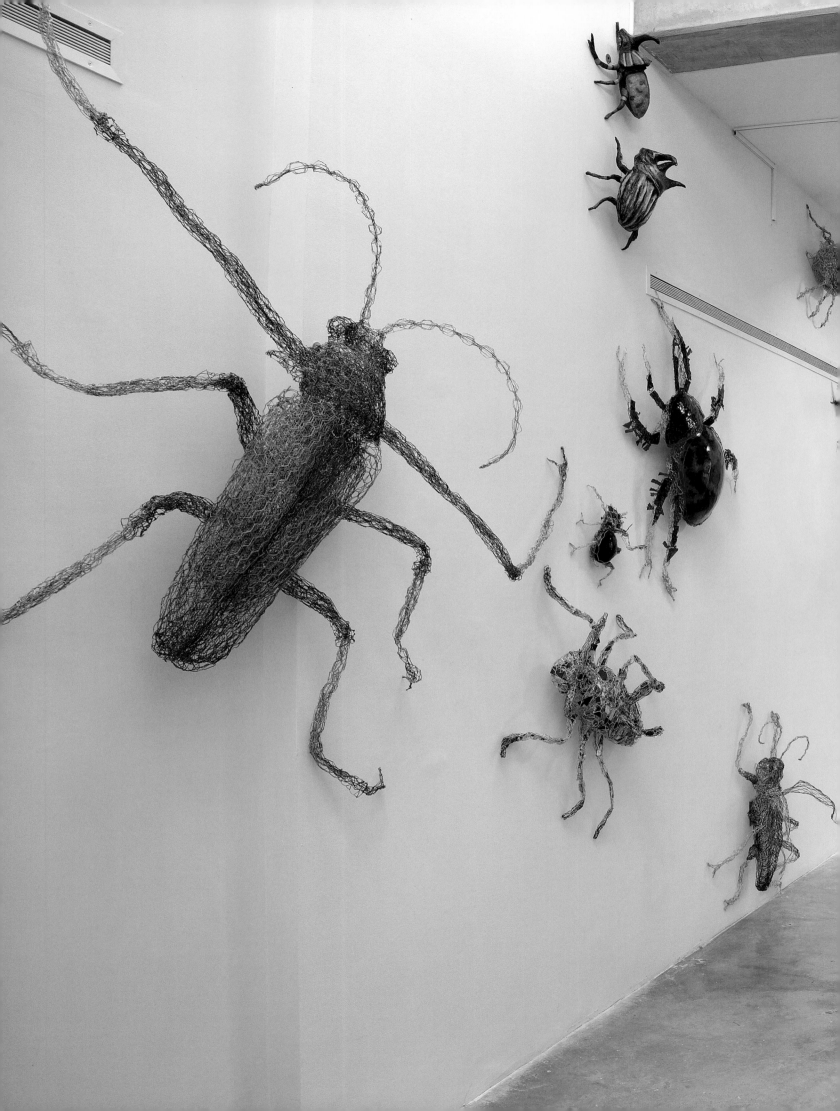

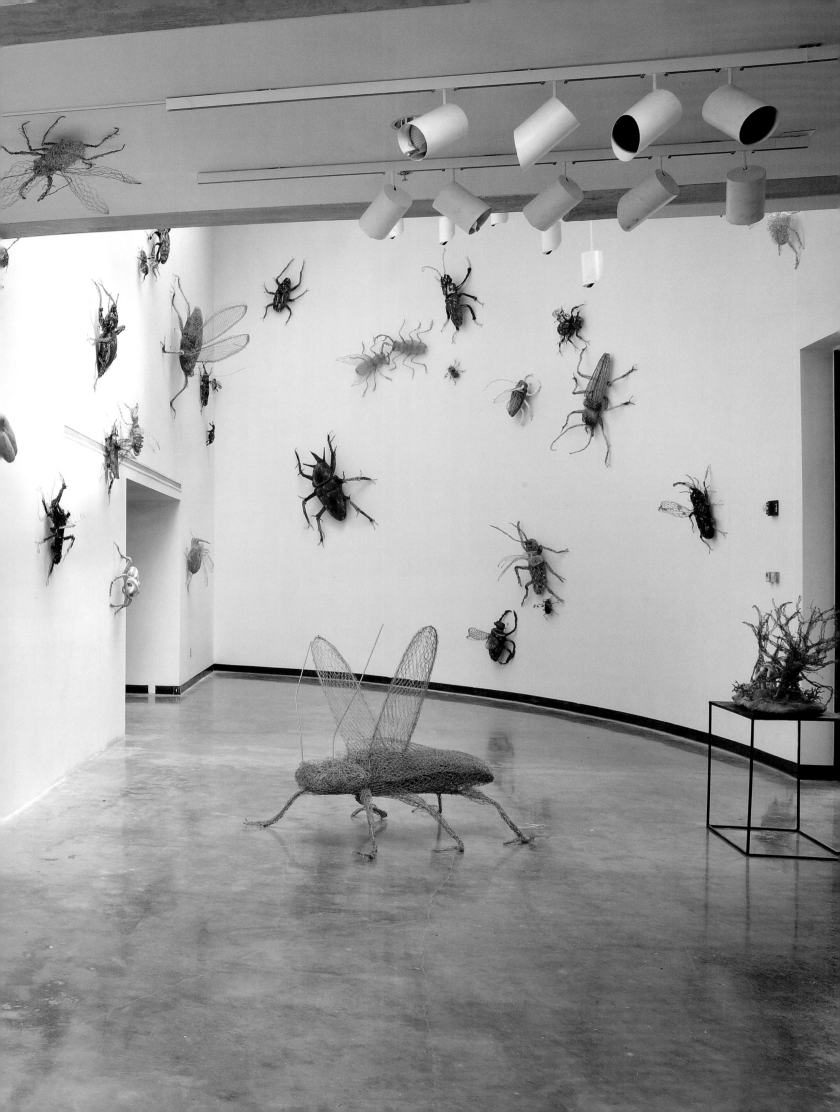

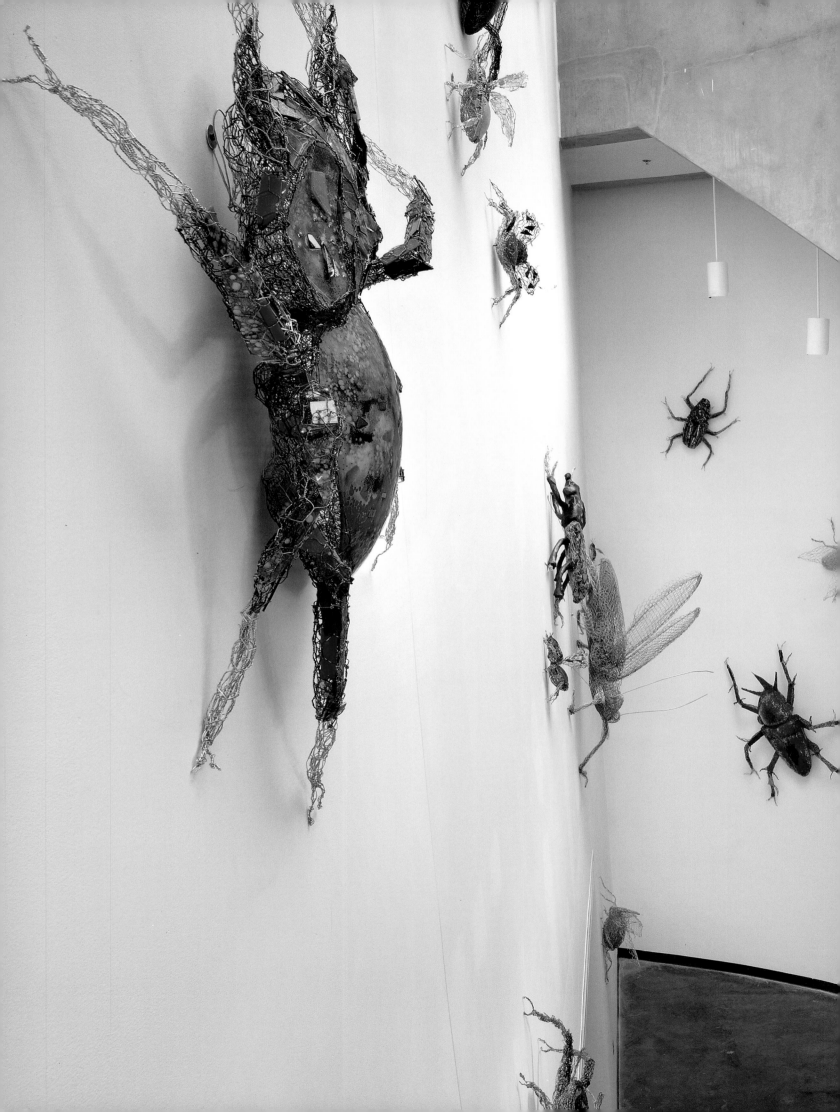

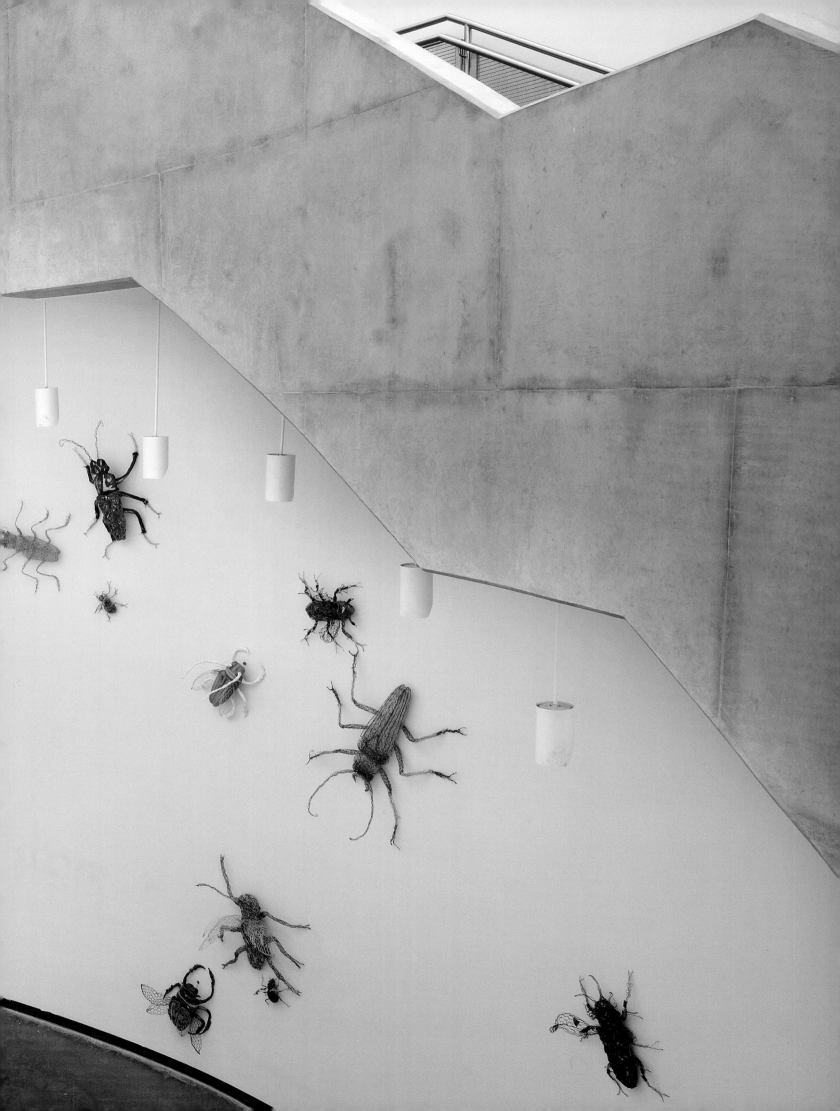

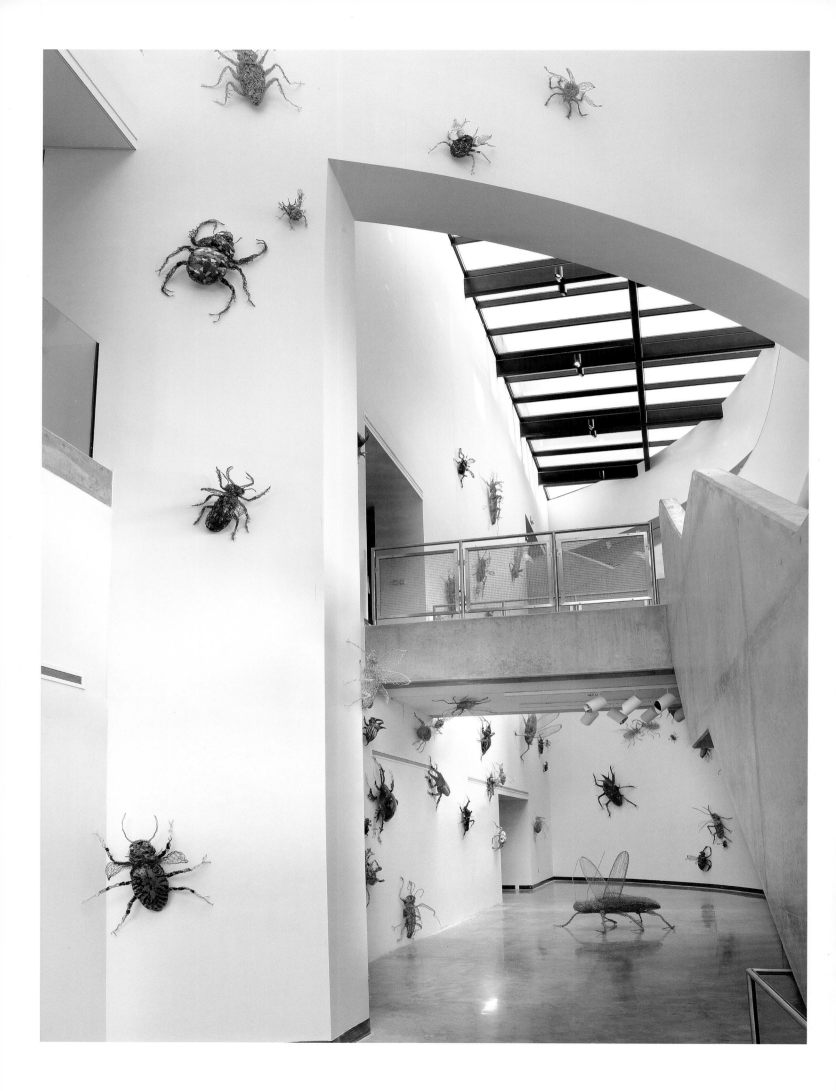

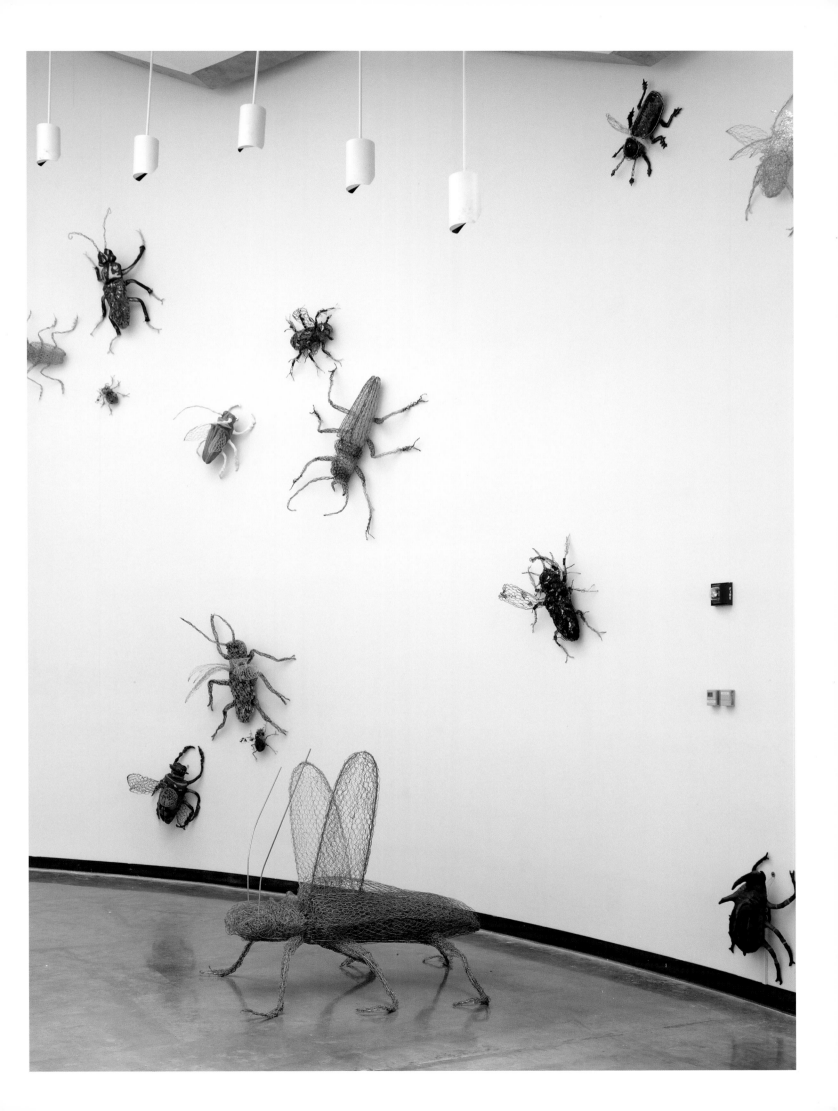

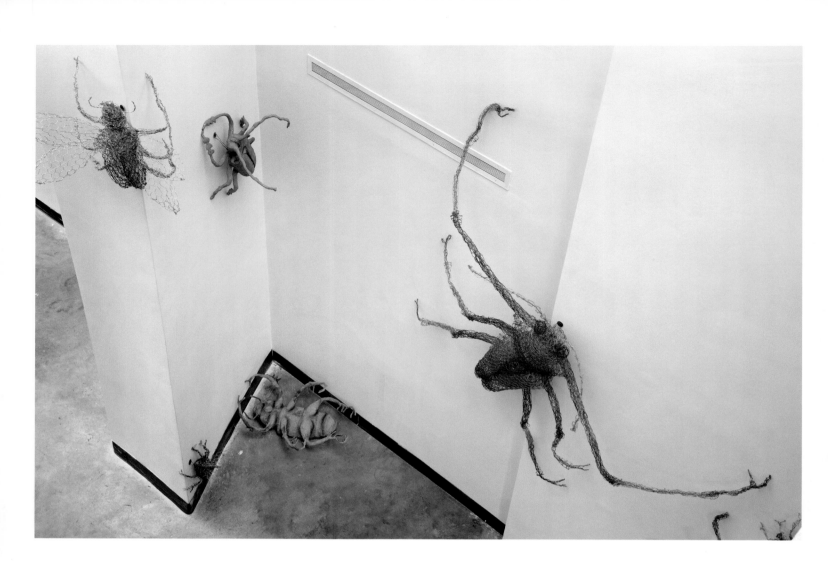

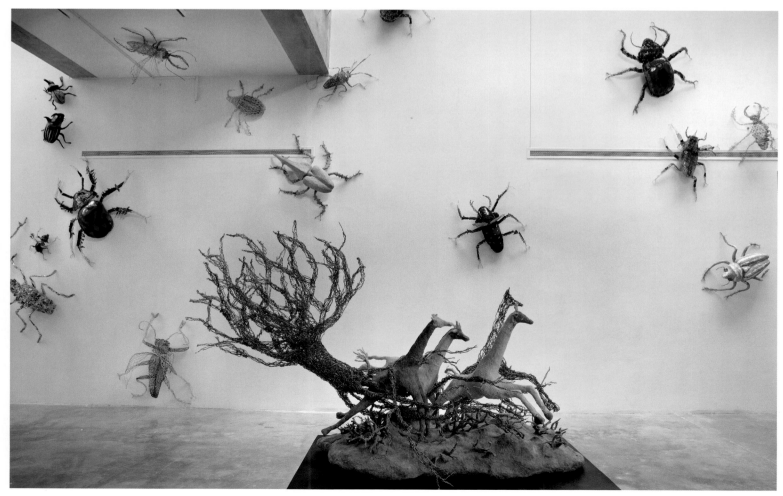

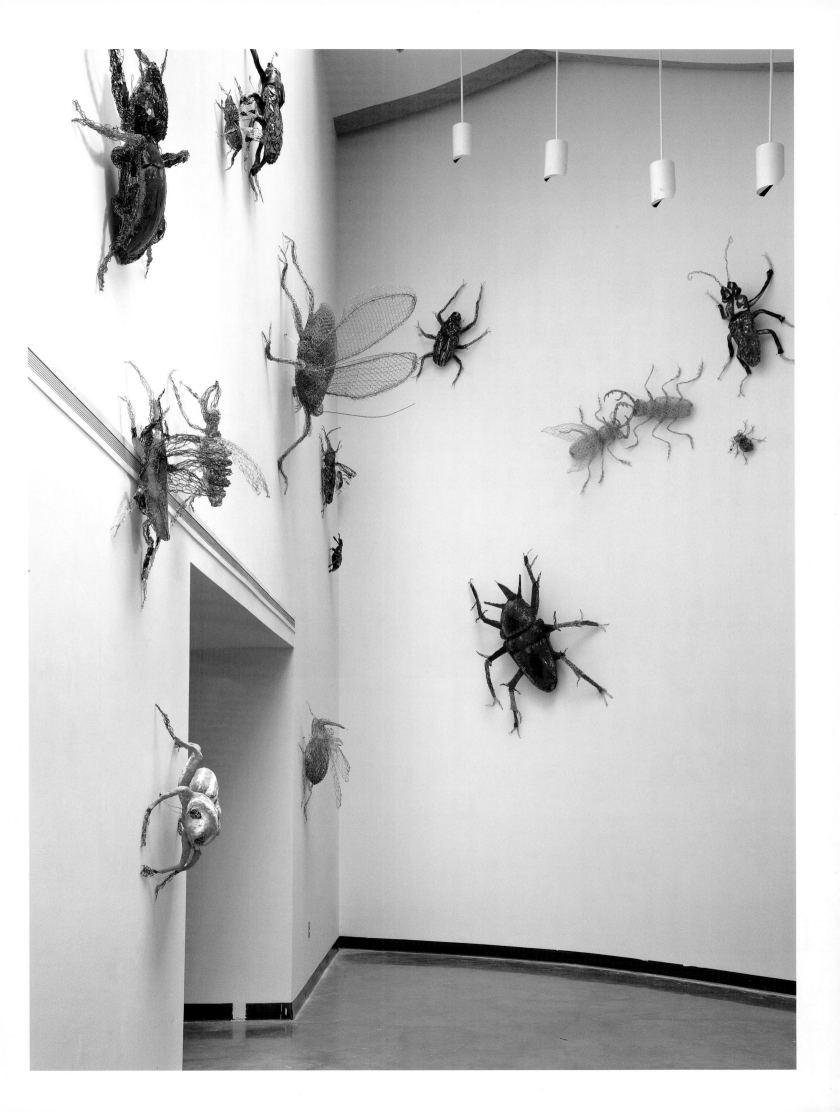

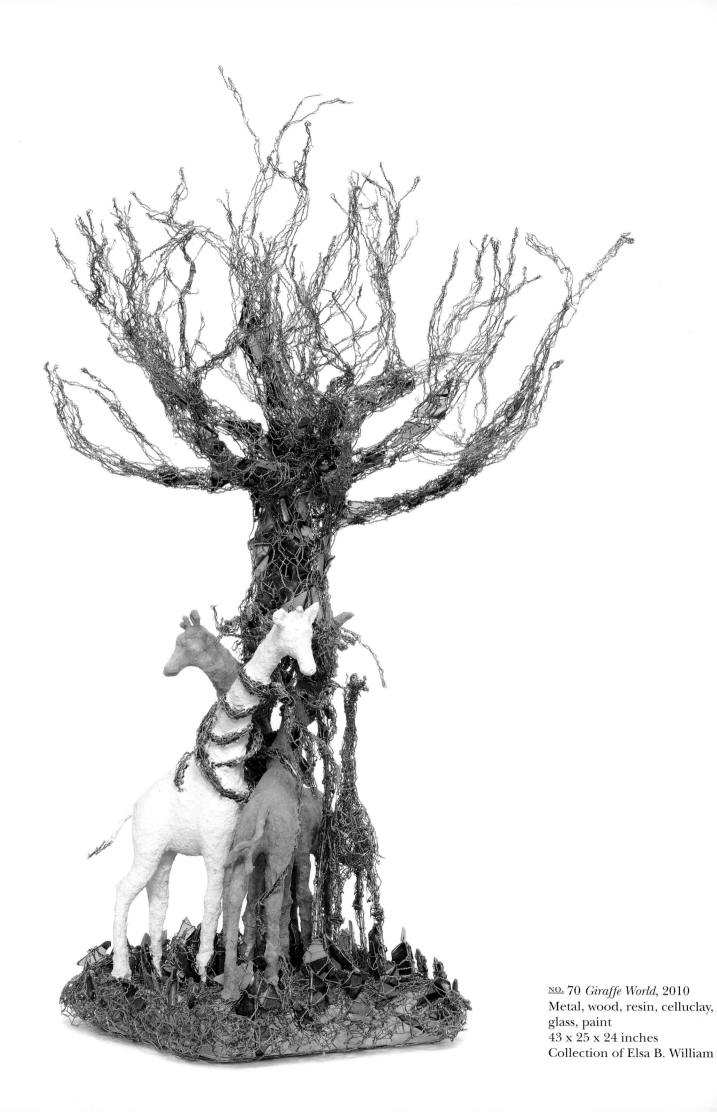

№ 70 *Giraffe World*, 2010
Metal, wood, resin, celluclay,
glass, paint
43 x 25 x 24 inches
Collection of Elsa B. William

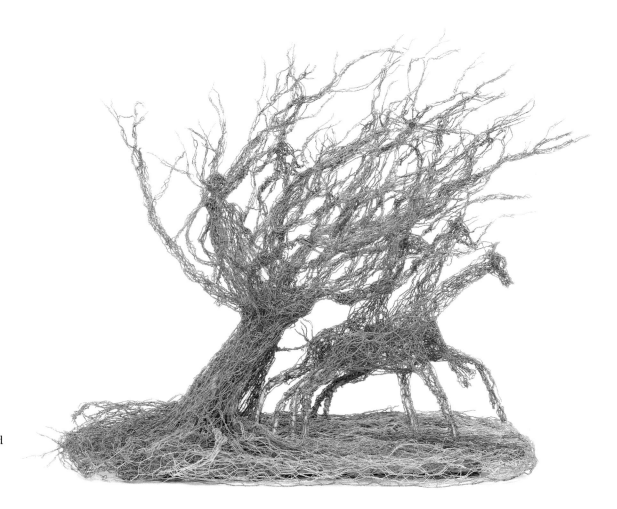

<u>NO.</u> 71 *Flying Trees*, 2010
Metal armature, wire, wood
27 x 40 x 21 inches

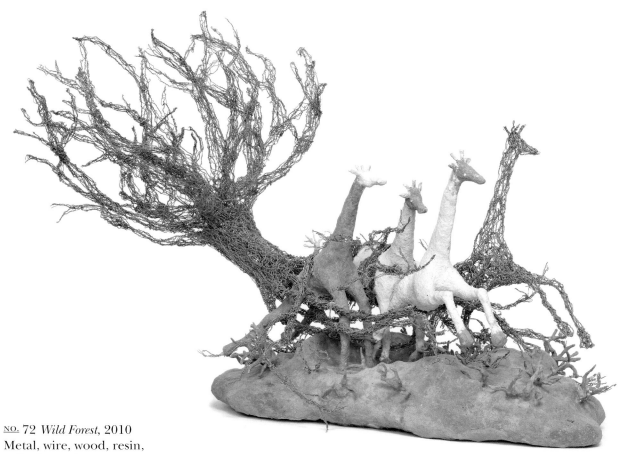

<u>NO.</u> 72 *Wild Forest*, 2010
Metal, wire, wood, resin,
celluclay, paint
29 x 27 x 29 inches

JOAN DANZIGER: CHRONOLOGY

Lives and Works In Washington, DC

SITE–SPECIFIC PUBLIC ART COMMISSIONS (1993-2007)

Permanent Installation for DC Commission for The Arts
Kennedy Recreation Center, Washington, DC
Acrobatic Troupe

Party Animals. DC Commission for The Arts
Eagle Riding High

Grounds for Sculpture, Hamilton, New Jersey
Comissioned by The Sculpture Foundation
October Gathering, cast bronze

Fish Out Of Water Project
The Downtown Partnership of Baltimore, Maryland
Blue Man On A Fish

George M. Taylor Multi-Service Center,
Glen Burnie, Maryland
State of Maryland Art In Public Place Commission
Aerial Conjunction, three suspended Sculptures and
two wall sculptures

Washington DC Convention Center, Washington, DC
Acrobatic Troupe, three suspended sculptures in a
40 x 60 feet atrium

George Meany Labor Studies Center, Maryland
National Endowment for the Arts Commission
Three 8' figurative sculptures

Frostburg State College, Student Union,
Frostburg, Maryland
18.5' suspended sculpture comprised of three
figures in a 60' atrium

SOLO EXHIBITIONS (1973-2012)

American University Museum, Katzen Arts Center,
Washington, DC

Osuna Gallery, Washington, DC

Southwest Art Center, San Antonio, Texas

Kelton Mathes Development Corporation,
Arlington, Texas

Textile Museum, Washington, DC

Louisiana World Exposition, New Orleans, Louisiana

Rutgers University, New Brunswick, New Jersey

New Jersey State Museum, Trenton, New Jersey

Joy Horwick Gallery, Chicago, Illinois

Terry Dintenfass Gallery, New York, New York

Jacksonville Museum of Art & Sciences,
Jacksonville, Florida

New York State University Art Gallery, Albany, New York

Mead Corporation International HQ, Dayton, Ohio

Fendrick Gallery, Washington, DC

University of Maryland, Baltimore, Maryland

Muckenthaler Cultural Center, Fullerton, California

California Museum of Science & Industry,
Los Angeles, California

Corcoran Gallery of Art, Washington, DC

Henri Gallery, Washington, DC

Simone Stern Gallery, New Orleans, Louisiana

SELECTED GROUP EXHIBITIONS (1974-2007)

Washington Women In The Arts: A Selection,
Osuna Gallery, Washington, DC

Society of Art of The Imagination, Cork Gallery,
London, England

Grounds for Sculpture, Hamilton, New Jersey

Fantasy & Dreams, Susquehanna Art Museum,
Harrisburg, Pennsylvania

International Sculpture Conference, Benjamin Mangel
Gallery, Philadelphia, Pennsylvania

City Spaces, Antheneum Museum, Alexandria, Virginia

Noah Seeing Anew, Virginia Museum of Art,
Richmond, Virginia

Animal Imagery in Contemporary Art, Virginia Museum
of Art, Richmond, Virginia

*Figure & Fantasy & Animal Images — Contemporary
Objects & The Beast*, Renwick Gallery, Smithsonian
American Art Museum, Washington, DC

Taft Menagerie, Taft Museum, Cincinnati, Ohio

Paper, Dayton Art Institute, Dayton, Ohio

*Images of the '70s — 9 Washington Artists & New
Sculpture: Baltimore, Washington*, Corcoran Gallery of
Art, Washington, DC

Gems of Imagination, Art Museum of South Texas,
Corpus Christi, Texas

100 Artists Commemorate 200 Years, Xerox
Corporation, Rochester, New York

26th Street Playground Show, Baltimore Museum of
Art, Baltimore, Maryland

Fascinating Cat, Mulvane Art Center, Topeka & Wichita Art Museum, Kansas

Curious Creatures & Bizarre Beasts, Monmouth Museum, Lincroft, New Jersey

Suspended Sculptures, New Orleans Museum of Art, New Orleans, Louisiana

Washington Artists, The Phillips Collection, Washington, DC

PUBLIC COLLECTIONS

District of Columbia, Mayor's Office

New Orleans Museum of Art, New Orleans, Louisiana

New Jersey State Museum, Trenton, New Jersey

Jacksonville Museum of Arts & Science, Jacksonville, Florida

Capital Children's Museum, Washington, DC

National Museum of Women in the Arts, Washington, DC (Three sculptures)

Georgetown Day School, Washington, DC

American University, Washington, DC

Susquehanna Art Museum, Harrisburg, PA

CORPORATE COLLECTIONS

Artery Corporation, Chevy Chase, Maryland

Discovery Channel, Silver Springs, Maryland

Peat Marwick, Washington, DC

Plaza of the Americas Hotel, Dallas, Texas

GRANTS

George Meany Labor Studies Center, Maryland Artist-in-Residence, funded by The National Endowment for the Arts

Louisiana World Exposition, World's Fair, New Orleans, Louisiana Exhibiton and Artist-In-residence

ARTISTS RESIDENCY

American Academy In Rome, Rome, Italy Six week residency

Skopelos Foundation For The Arts, Skopelos, Greece Print Making Facility. Invited to print a series of woodcuts.

Cité International Des Arts, Paris, France

Awarded by the American Center. Worked on Ideas for an Exhibition at the Textile Museum—Textures & Tapestries. Two month residency.

EDUCATION

Cornell University (B.F.A.)

The Arts Students League of New York, New York

The Academy of Fine Arts, Rome, Italy

ART ORGANIZATIONS

Visual Arts Panelist for The DC Commission On The Arts & Humanities, Washington, DC

Visual Arts Panelist for The New Jersey State Council on the Arts, New Jersey

Sculpture Guild, New York, New York

Society of Art of the Imagination, London, England

Advisory Board member for the Washington Sculptors Group, Washington, DC

Art Committee Member of the Cosmos Club, Washington, DC

LISTINGS

Who's Who in American Art & International Art

Who's Who of American Women & Eastern Art

Contemporary American Women Sculptors

World's Women Artists

100 Artists of the Mid-Atlantic

MATERIALS

Sculpture: Mixed Media — wire, wood and metal armature, resin reinforced fabric, celluclay, acrylic paint

Glass Sculptures: Metal armature, frit, dichroic glass, fused glass, acrylic paint

WEBSITE

www.joandanziger.com

CONTACT

+1 (202) 686.5285

joansculp@aol.com

The sculptures were all created in 2011 and 2012. Dimensions of sculptures are in inches (Height x Width x Depth).

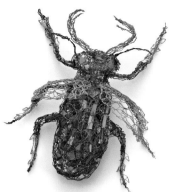

NO. 1 *Green Shiny Beetle*, 2011
20 x 16 x 12 inches

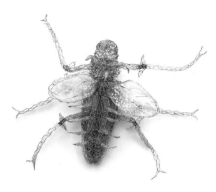

NO. 2 *Glass Wing Beetle*, 2012
35 x 40 x 15 inches

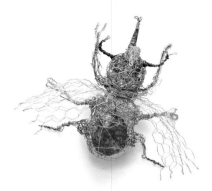

NO. 3 *Gypsy Beetle*, 2012
9 x 8 x 14 inches

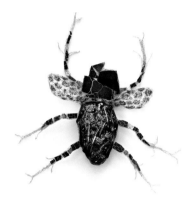

NO. 4 *Constructivist Beetle*, 2012
60 x 60 x 10 inches

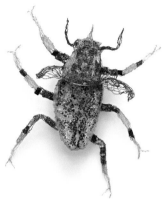

NO. 5 *Princess Beetle*, 2011
30 x 27 x 14 inches

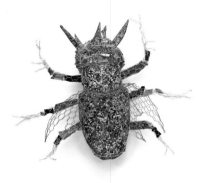

NO. 6 *Red Devil Beetle*, 2012
20 x 37 x 19 inches

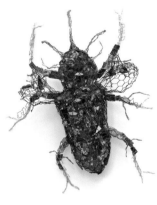

NO. 7 *Plume Beetle*, 2012
31 x 20 x 15 inches

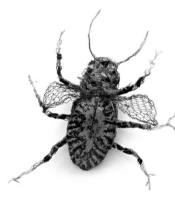

NO. 8 *Tiger Beetle*, 2011
38 x 28 x 14 inches

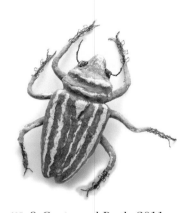

NO. 9 *Creepy-eyed Beetle*, 2011
10 x 24 x 27 inches

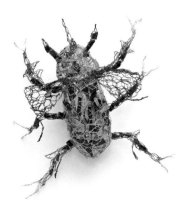

NO. 10 *Honey Beetle*, 2011
26 x 25 x 14 inches

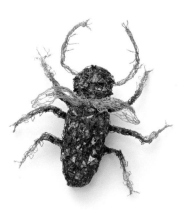

NO. 11 *Blue Mosaic Beetle*, 2012
24 x 25 x 8 inches

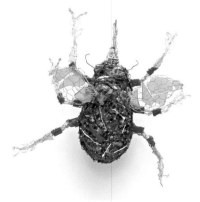

NO. 12 *Lace Wing Beetle*, 2012
17 x 14 x 7 inches

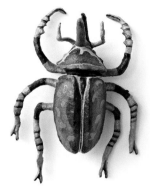

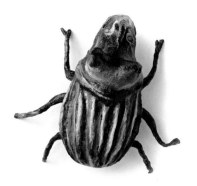

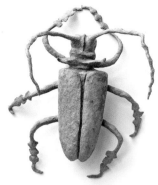

NO. 13 *Contessa Beetle,* 2012
23 x 18 x 10 inches

NO. 14 *Rhino Beetle,* 2011
15 x 2 x 9 inches

NO. 15 *Hermit Beetle,* 2011
9 x 8 x 14 inches

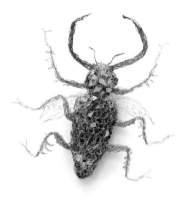

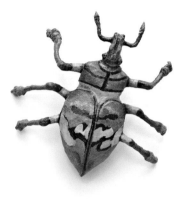

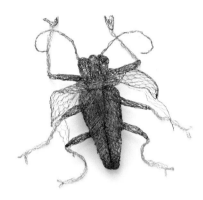

NO. 16 *Ornate Beetle,* 2011
18 x 19 x 7 inches

NO. 17 *Orange Tail Beetle,* 2011
14 x 13 x 4 inches

NO. 18 *Copper Wing Beetle,* 2011
35 x 29 x 15.5 inches

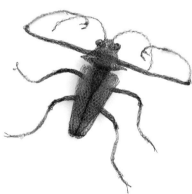

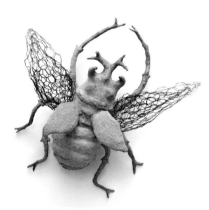

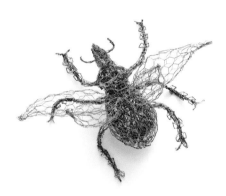

NO. 19 *Vampire Beetle,* 2012
52 x 60 x 10 inches

NO. 20 *Black Magic Beetle,* 2011
25 x 27 x 14 inches

NO. 21 *Upright Wire Beetle,* 2012
16 x 24 x 12 inches

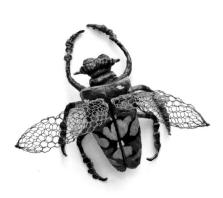

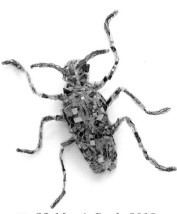

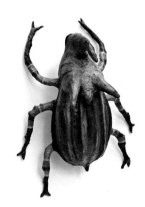

NO. 22 *Summer Beetle,* 2011
30 x 25 x 28 inches

NO. 23 *Mosaic Beetle,* 2012
19 x 15 x 11 inches

NO. 24 *Red Rhino Beetle,* 2011
23 x 11 x 17 inches

43

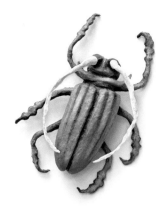

NO. 25 *White Horned Beetle*, 2012
23 x 18 x 12 inches

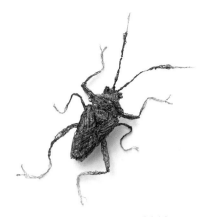

NO. 26 *Electric Beetle*, 2012
31 x 25 x 13 inches

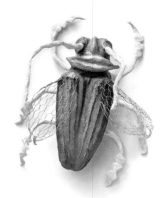

NO. 27 *Long Horned Beetle*, 2011
9 x 8 x 14 inches

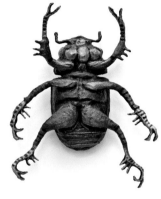

NO. 28 *Upside Down Painted Beetle*, 2011
24 x 19 x 6 inches

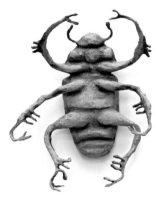

NO. 29 *Upside Down Ash Beetle*, 2012
25 x 24 x 13 inches

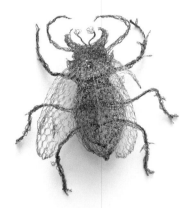

NO. 30 *Butterfly Wire Beetle*, 2012
23 x 27 x 11 inches

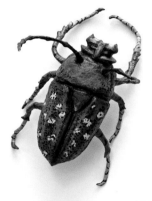

NO. 31 *Woodland Beetle*, 2011
21 x 13 x 17 inches

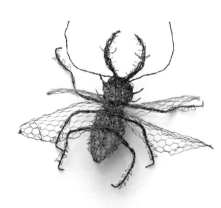

NO. 32 *Chopper Beetle*, 2012
25 x 29 x 12.5 inches

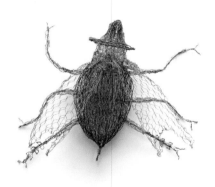

NO. 33 *Horn Beetle*, 2011
26 x 20 x 12 inches

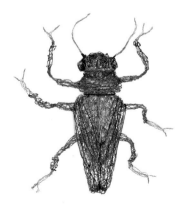

NO. 34 *Blackeyed Beetle*, 2012
23 x 27 x 11 inches

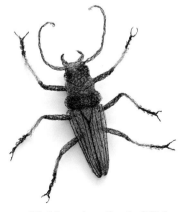

NO. 35 *Mysterious Beetle*, 2011
45 x 48 x 20 inches

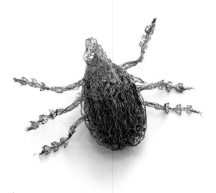

NO. 36 *Gourmet Beetle*, 2012
14 x 22 x 9 inches

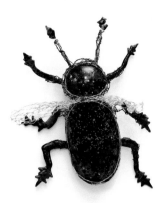

NO. 37 *Night Beetle 2*, 2012
22 x 14 x 2.5 inches

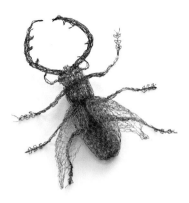

NO. 38 *Stag Beetle Wings*, 2011
32 x 24 x 19 inches

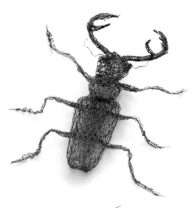

NO. 39 *Stag Beetle*, 2011
31 x 30 x 9 inches

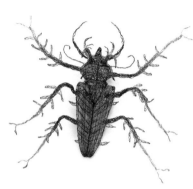

NO. 40 *Copper Devil Beetle*, 2012
60 x 54 x 9 inches

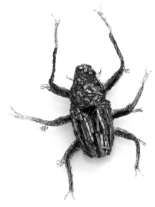

NO. 41 *Stripe Beetle*, 2011
40 x 30 x 7 inches

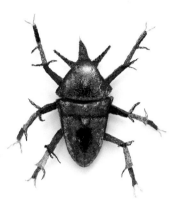

NO. 42 *Warrior Beetle*, 2012
72 x 65 x 15 inches

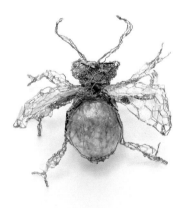

NO. 43 *Fairy Beetle*, 2012
17 x 15 x 9 inches

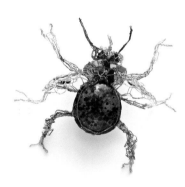

NO. 44 *Blue Beetle*, 2012
13 x 11 x 6 inches
Collection of Vivian Pollack

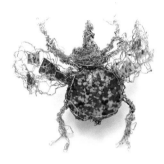

NO. 45 *Gold Beetle*, 2012
10 x 11 x 7 inches
Collection of Jean Norcut

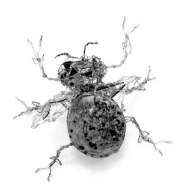

NO. 46 *Lime Green Beetle*, 2012
13 x 11.5 x 9 inches
Collection of Laurel Mendelson

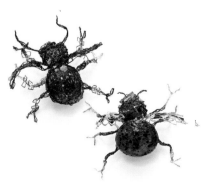

NO. 47 *Green Wing & Red Blue Beetles*,
2012
12 x 11 x 7 inches & 10 x 10 x 6 inches

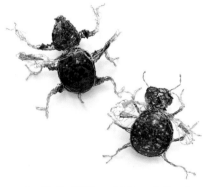

NO. 48 *Red Wing & Purple Beetles*,
2012
9 x 13 x 9 inches & 10 x 11 x 9 inches

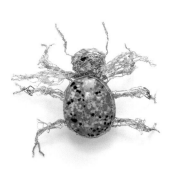

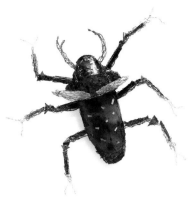

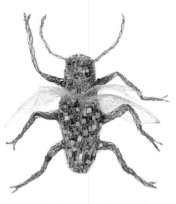

NO. 49 *Tangerine Beetle*, 2012
12 x 11 x 8 inches

NO. 50 *Shimmering Beetle*, 2012
33 x 32 x 10.5 inches
Collection of Carol Brown Goldberg
and Henry Goldberg

NO. 51 *Retro Beetle*, 2012
41 x 33 x 21 inches

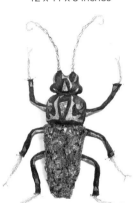

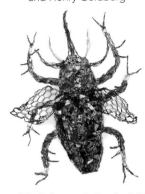

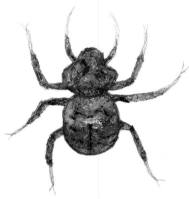

NO. 52 *King Beetle*, 2011
46 x 29 x 13 inches

NO. 53 *Sabertooth Beetle*, 2012
29 x 24 x 11 inches
Private Collection

NO. 54 *Emerald Beetle*, 2012
20 x 37 x 19 inches

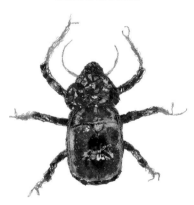

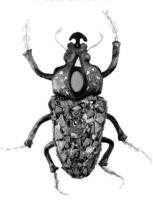

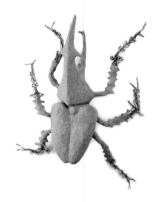

NO. 55 *Red Beetle*, 2011
39 x 37 x 46 inches

NO. 56 *Golden Beetle*, 2011
36 x 33 x 9 inches

NO. 57 *Hercules Beetle*, 2011
34 x 25 x 8 inches

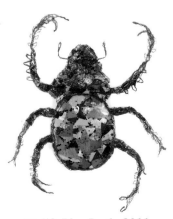

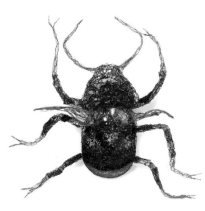

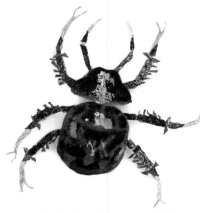

NO. 58 *Blue Beetle*, 2011
32 x 31 x 6 inches

NO. 59 *Amethyst Beetle*, 2012
41 x 38 x 10 inches
Private Collection of
Gisella and Ben Huberman

NO. 60 *Tortoise Beetle*, 2012
40 x 40 x 7 inches

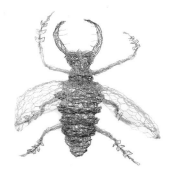

NO. 61 *Bumblebee*, 2011
26 x 16 x 12 inches

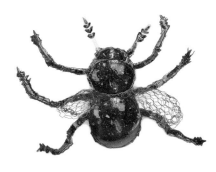

NO. 62 *Midnight Beetle*, 2012
23 x 29 x 12 inches

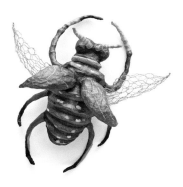

NO. 63 *Cardinal Beetle*, 2011
25 x 25 x 9 inches

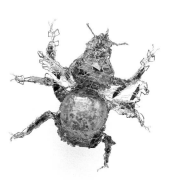

NO. 64 *Scarlet Lily Beetle*, 2012
12 x 13 x 8 inches

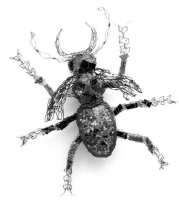

NO. 65 *Firebug Beetle*, 2012
17 x 11 x 7 inches

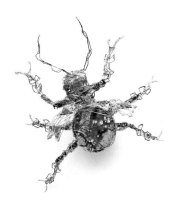

NO. 66 *Whirligig Beetle*, 2012
22 x 21 x 7 inches

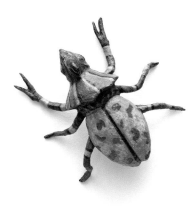

NO. 67 *Zoom Beetle*, 2011
13 x 14 x 8 inches
Collection of Kathy Borrus

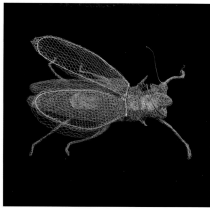

NO. 68 *Hera Beetle*, 2012
62 x 53 x 36 inches

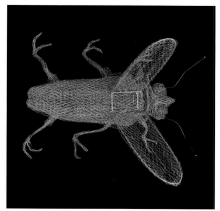

NO. 69 *Zeuss Beetle*, 2012
56 x 48 x 51 inches

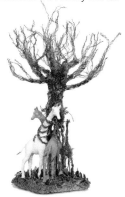

NO. 70 *Giraffe World*, 2010
43 x 25 x 24 inches
Collection of Elsa B. Williams

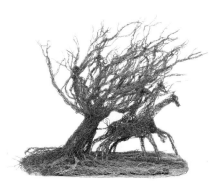

NO. 71 *Flying Trees*, 2010
27 x 40 x 21 inches

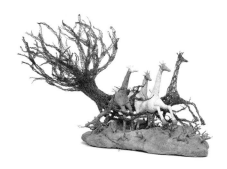

NO. 72 *Wild Forest*, 2010
29 x 27 x 29 inches

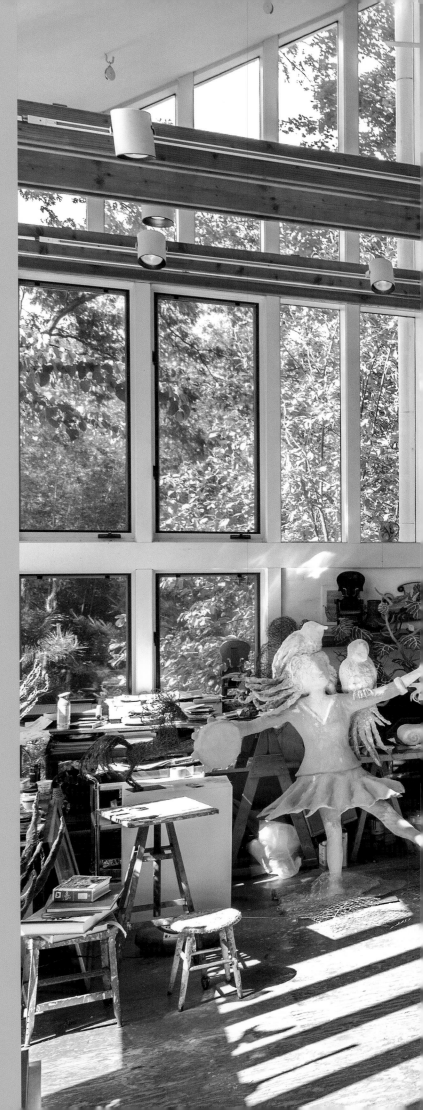

ACKNOWLEDGEMENTS

Elaine A. King
Lenore D. Miller
Jack Rasmussen
Ori Z. Soltes

ART ASSISTANT

Thanks to my talented assistant, Anna Meyer Zachurski, who has helped me with every aspect of this exhibition.

GRAPHIC DESIGN

Simon Fong
International Arts & Artists, Washington, DC
www.artsandartists.org

PHOTOGRAPHY

Neil Greentree
www.neilgreentree.com

The Rhino Is A Tree… The Tree Is A Rhino on page 10 by Alex Jamisen.

PRINTING

Linemark Printing, Upper Marlboro, Maryland